The
Restorer's Handbook
of
Easel Painting

Under the direction of Madeleine Hours, chief curator of the National Museums of France, Master of Research at the National Center for Scientific Research.

The
Restorer's Handbook
of
Easel Painting

Gilberte Emile-Mâle

 VAN NOSTRAND REINHOLD COMPANY

New York Cincinnati Toronto London Melbourne

English translation: J. A. Underwood

Copyright © 1976 by Office du Livre, Fribourg (Switzerland)

Library of Congress Catalog Card Number 76-15802

ISBN: 0-442-22301-3

Printed in Switzerland

Published in 1976 by Van Nostrand Reinhold Company
A division of Litton Educational Publishing, Inc.
450 West 33rd Street
New York, New York 10001

Van Nostrand Reinhold Limited
1410 Birchmount Road
Scarborough, Ontario MlP 2E7, Canada

16 15 14 13 12 11 10 9 8 7 6 5 4 3 2 1

Library of Congress Cataloging in Publication Data

Émile-Mâle, Gilberte.
The restorer's handbook of easel painting.

Translation of La restauration des peintures de chevalet.
Bibliography: p. 124
Includes index.
1. Paintings – Conservation and restoration – Handbooks, manuals, etc. 2. Artists' materials. I. Title.

ND1650.E4713 751.6 76-15802

ISBN 0-442-22301-3

TABLE OF CONTENTS

INTRODUCTION

There was the Florence flood of November 1966. There was Lascaux, which had to be closed to visitors in order to save the cave paintings. There are those disturbing loudspeakers in the gardens of the temples of Kyoto announcing that air pollution has now reached a dangerous level. Who, hearing about or experiencing these things, can fail to echo Germain Bazin's cry of alarm: "We have made a lot of fuss about this thing called the masterpiece: at the same time, by the immoderate use we make of it, we come close to treating it as if it were a perfectly ordinary commodity. Will there come a day when, in order to preserve something for the generations to come, works of art will have to be kept from those who would admire them?"[1]

The art-lover is often little aware of the problems involved in the conservation of the works of art in his possession. To the public and even to painters restoration remains something of a mystery, inspiring a certain mistrust as well as a curiosity that sometimes borders on the passionate.

What exactly do these words "conservation" and "restoration" mean?

Well, they mean something slightly different depending on where you hear them, which lends them an element of ambiguity. In the English-speaking countries the word "conservation" covers all the remedial attentions given to a work of art in order to prolong its life – but excluding all additions or reconstitutions. The word "restoration" refers to the reconstitution of missing material by additions that may be either visible or integrated and that complete the work by actually "restoring" its unity.[2] In France and the Latin countries the word "restoration" has a wider meaning: it covers not only the sum total of remedial attentions given to the work of art but also the reconstitution of missing portions, be they large or small. I am French, so it is in this broader connotation that I shall be using the word "restoration" here – i.e. including what my readers will understand by "conservation" as well.

The purpose of this brief handbook, then, is to throw some light on the "mystery" of restoration. It is aimed at both art-lovers and students. It seeks to put collectors on their guard against confiding their pictures to ignorant or dishonest restorers as well as against the dangers, in this field, of "do-it-yourself". (The practice of cleaning paintings with a halved raw potato is, one would hope, a thing of

the past!) It further seeks to promote in all those concerned to preserve our cultural heritage an awareness of and respect for the fundamental rules of conservation. To student and artist readers it seeks to demonstrate the complexity of a profession that, though little-known, is an exciting and responsible one. Finally, it would hope to discourage the impulsive and those who may be after a quick way of making money. It takes a real vocation to be prepared to work for ten years before one can say that one is a master of one's craft!

Every country has its own methods of restoration, evolved through long experience. Moreover research is constantly in progress in one corner of the world or another. So there can be no question today of dishing up dodges and tricks of the trade in the manner of certain nineteenth-century manuals – which the modern restorer reads with a mixture of amusement and horror. The empirical approach is out. Numerous as are the products available to the restorer of today, they are all as it were permanently provisional in character, owing to the continuing progress of chemical science. The fact remains, however, that it is the way in which a product is used that really counts.

Every work in need of restoration is a case apart. Nevertheless it is possible to state certain general principles, the most important of which is: *Remove as much as possible of what men and time have added to the work, while yourself adding as little as possible.*

Restoration is a technical operation the object of which is to prolong the life of a work of art by slowing down the process of decay affecting the materials of which it is made. Restoration is also a critical operation aimed at achieving a balance between two requirements: historical honesty and aesthetic pleasure. The work of art as message offered to the general public, including the ill-informed, requires that the restorer should reinstate its pictorial unity; as witness to the ages through which it has come down to us it requires the restorer to respect its historical testimony. The solutions arising out of a balance of these two requirements[3] are further subject to the three musts of modern restoration: legibility, stability, and reversibility.

Legibility is essential to the spectator's enjoyment of the work. It calls for retouching (but of the damaged areas only) of a kind that is detectable by laboratory examination or with the naked eye at close quarters, though not from a distance.

A further essential requirement is *stability* in the materials employed. This is a problem that preoccupies all restorers. It is aggravated by the progressive disappearance of those natural materials that have proved themselves over the centuries and by our inability to tell as yet how our new materials will stand the test of time.

Reversibility is a modern requirement. Every solution ist provisional; it prolongs the life of a work, but not, as the restorers of the eighteenth and nineteenth centuries believed, to infinity. Today's restorers take a more modest view: any material added to a work must be capable of being removed at any time without damage to the original. But although this kind of reversibility is possible as regards retouching, it is not as regards cleaning, reducing the varnish layer, or devarnishing – all operations of the greatest importance as far as the future of a painting is concerned.

Restoration (in the very widest sense) is as old as artistic creation itself. In the Middle Ages pictures

were adapted to the taste of the day by pious hands.[4] Famous artists retouched the works of their predecessors: Duccio, Guido da Siena, Lorenzo di Credi, Angelico.[5] In the sixteenth and seventeenth centuries painters of renown continued to *rifiorire* (literally "reflower") older works: Primatice restored François I's Raphaels; Carlo Maratti restored the Stanze, the suite of rooms that Raphael had decorated in the Vatican.[6] In princely galleries up and down Europe artists enlarged or reduced paintings to make them fit into a particular decorative scheme.[7]

For centuries the decorative aspect was paramount; historical respect for artistic creation was something quite unknown.

It was the eighteenth century that saw the birth of restoration properly speaking – in other words that first made a distinction between the painter and the restorer. New techniques were invented or gained ground: transfer, which replaced the original support with a new one; the sliding cradle, which allowed a wooden support free play. Italy and France led the field here, Italy inventing the transfer process around 1714–20[8] and France employing it officially for the first time around 1746–50. The transfer of Andrea del Sarto's *Charity* (Louvre) by Robert Picault was quite an event.

The French Revolution, the opening of the Louvre Museum in 1793, and the arrival in Paris of paintings from all over Europe as a result of Napoleon's campaigns stimulated a big increase in restoring activity, which thereafter became more organized and better regulated.[9]

The transfer of Raphael's *Foligno Madonna* (Vatican Museum) by François Hacquin in Paris in 1799–1800 occasioned the publication of a famous report, thus removing the veil of mystery and acknowledging the public's right to be informed. For the first time a control commission was appointed with representatives from various disciplines including chemistry. It was the dawn of collaboration between three types of expert: the art historian, the technician, and the scientist.[10]

Around the same time P. Edwards set up the "Laboratorio de San Giovanni e Paolo" in Venice, where for nearly twenty years he practised methods of restoration that were very much in line with modern principles.

The nineteenth century ushered in every kind of contradiction. While some restorers were already respecting the principles that govern restoration in our own day, others continued the obscurantist tradition, jealously guarding their "secrets" and posing as virtual magicians.

The early nineteenth century was the era of the "golden glow", the muffling effect that comes from successive coats of varnish having yellowed with age (in France we call it "museum juice"). This taste for the patina of time was one of the nostalgic manifestations of the Age of Romanticism.

Towards the middle of the century certain pioneers – Eastlake of the London National Gallery, Villot of the Louvre – had a number of pictures stripped of their obscuring coats of varnish. The result: a scandalized public forced them to resign. Then the alcohol-vapor method of reconditioning varnish, invented by the German Pettenkofer, seemed for a time to offer a miracle solution, rendering what was thought to be the dangerous process of devarnishing unnecessary.

With the twentieth century restoration has gradually emerged from empiricism to enter a more con-

sidered and more organized phase. Specialists the world over have been at pains to define and put into practice the guiding principles of modern restoration. Studios and institutes devoted to this task have been set up and continue to be set up throughout the Old and New Worlds, with publications to disseminate their findings. International organizations – ICOM (International Council of Museums), the intergovernmental body set up by UNESCO in Paris in 1948; IIC (International Institute for Conservation of Historic and Artistic Works), an interprofessional group founded in London in 1950 – hold conferences of experts who take stock of the problems in their respective journals.[11] In 1959 UNESCO established the International Study Center for the Conservation and Restoration of Works of Art with headquarters in Rome. Its brief is to train experts, disseminate information, and answer appeals from member countries. The work of training experts is going on everywhere. At the same time there is a new and growing tendency to regard the great masterpieces of painting as supranational treasures. The responsibility of restoring them is so great that it must be shared among experts from a number of countries. But in the final analysis the restorer, even when he can draw on the most enlightened advice and consult the most penetrating studies, is alone in actually putting his hand to the priceless object in question.

What is the ideal training for an art restorer nowadays?

Well, the obvious and indispensable basis both for understanding the work and its technique and for effectively retouching any missing portions is of course a thorough knowledge of drawing and painting. The execution of a piece of modulated *tratteggio* retouching or the invisible reconstitution of part of a face (as has to be done sometimes) will be quite beyond anyone who does not know how to paint. This artistic training will then be complemented by a study of the various techniques of painting as well as of art history and the history and theory of restoration. A certain minimum of scientific knowledge – chemistry, physics, optical examination methods, the interpretation of documents – is likewise indispensable. Finally – and this is perhaps the most important part – the student must practice the techniques of restoration in a studio for a number of years.[12]

But none of this training will serve any purpose if the would-be restorer is not in possession of certain personal qualities: an aptitude for this type of work, an understanding of what painting is about, and a keen moral sense – which is the only thing that will safeguard his professional honesty and steer him clear of the many temptations that assault the restorer in his work. It will be a big step in the right direction when, throughout the world, the profession of art restorer receives the respect – the very great respect – that it deserves.

1
School of Fontainbleau, *Portrait of a Woman* (Louvre, Paris).

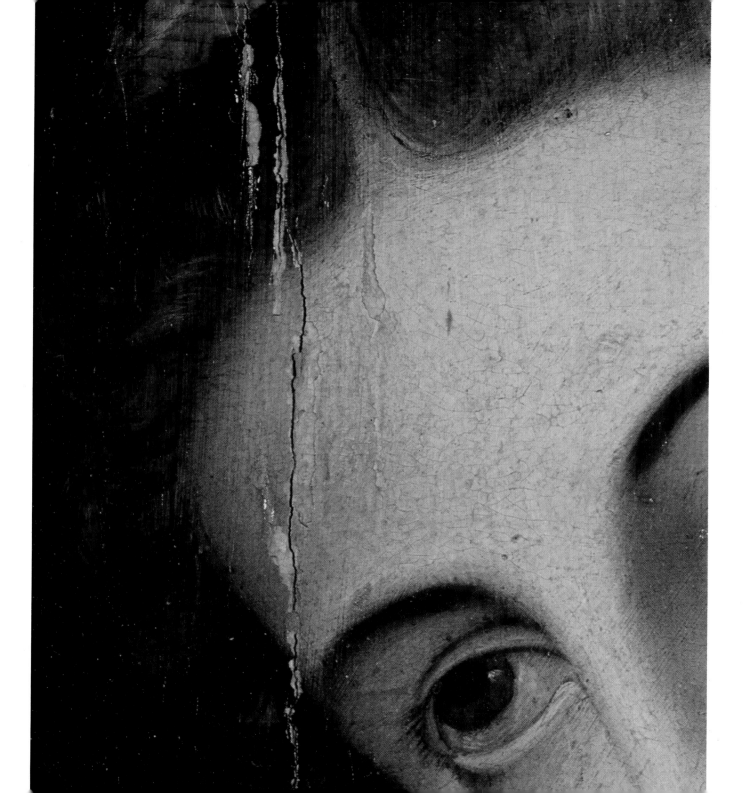

WOOD

The support that easel painters have been using for longest is wood. Indeed they used little else up until the Renaissance, when canvas largely replaced it. The ancient Greeks kept their painting treasures in a "pinacotheca" (from *pinas:* a "board" or "tablet". The "mummy portraits" that the Egyptians used to paint on wood and place on the face of the deceased inside the wrappings were followed between the first and fourth centuries A.D. by the personalized Romano-Egyptian portraits of Fayyum, also painted on wooden supports. Then, from the end of the sixth century onwards, artists all round the Mediterranean Basin began to represent God and the Virgin in the form of icons painted likewise on wood.

2
Warping: The wood is gradually drying out. It does so faster on the unpainted back of the panel, the paint layer on the front forming a kind of screen. No action is called for here; the warping is due to the natural process of aging and does not mar the work aesthetically. Andrea di Giusto, *Crucifixion* (Petit Palais, Avignon).

The heyday of the wooden panel as a support for painting was in the fourteenth and fifteenth centuries in southern Europe and the fifteenth and sixteenth centuries in northern Europe, where wood continued to be used alongside canvas in the seventeenth century as well. There was a general revival of interest in painting on wood in the nineteenth century.

The type of wood used by an artist may help to place him, because from the eleventh to the sixteenth centuries artists mostly painted on panels made from locally-cut timber. In Italy, for example, we find mainly poplar, in Spain both pine and poplar, in Flanders and northern France oak, and in the South of France walnut, chestnut, and lime.[13]

Conservation[14]

How long a wooden panel will last depends on a number of factors.
Of great importance is the *type of wood* selected (i.e. whether a hardwood or a softwood). Oak, for

13

example, lasts longer than poplar, which is highly susceptible to woodworm. The oak panels of the northern schools have come down to us in very much better condition than the poplar panels of the Italian schools.

The *quality* of the wood is also decisive. Boards cut from close to the heart of the trunk, being harder and denser, last longer and are less susceptible to woodworm than boards cut from the vicinity of the bark or sapwood. Knots, whether due to branches or growth defects, constitute weak points in a panel.

Correct *pre-treatment and seasoning* can make a great deal of difference. The seasoning process can be speeded up by floating the cut timber in order to remove the sap, which dissolves in water. This method also offers protection against mildew and worm. The amazing state of preservation of the oak panels used by northern-European painters is due in part to this treatment.

Finally there is what is referred to in the timber trade as "conversion", i.e. the *way in which the wood is sawn*. Wood is a living, hygroscopic material:[15] when it absorbs water it swells and when it loses that water it shrinks. This interchange between wood and the air around it is governed by the relative humidity of the latter. The alternation of swelling and shrinking is referred to as "play". The more recent the piece of wood, the greater the degree of play it will exhibit. Wood dries out gradually as it ages, but even a very old piece will still exhibit a residual amount of play.[16]

This play is not the same in every direction. Tangentially it is considerable, radially it is very limited, and axially it is practically non-existent (see fig. 2). Or, to put it another way, a piece of wood will show most play in the direction lying at right angles to the grain. This fact is extremely important as regards the conservation of panel paintings and we shall be coming back to it again and again.

The way a piece of wood shrinks is largely determined by the way in which it was sawn.

In slab-cut timber, i.e. wood sawn lengthways, play being greater towards the outside (where the wood is less dense) than towards the heart, the effects of seasoning are more pronounced in the direction CD than in the direction AB, with the result that the panel warps (fig. 8).

In wood cut radially or "on the quarter", as it is called, since play is again greater towards the outside than towards the heart, BC is subject to greater stress during seasoning than AD. Consequently the panel does not warp but becomes very slightly thinner at one end (fig. 9). The very fine Flemish panels that have come down to us perfectly flat were sawn "on the quarter."

These laws of nature also govern panels that are made up of several boards.

If three slab-cut boards are fixed at the ends they will form three separate cambers. The result is a corrugated panel (fig. 10).

If the same boards are left free at the ends the cambering effect will be cumulative, resulting in a curved panel (fig. 11).

If the boards are placed in opposite directions and the ends again left free, each will evolve in its own way and the panel will acquire a triple curvature (fig. 12).

Even this rapid survey shows clearly the importance of careful selection if a panel is to last a long time and age normally. Man was familiar with these

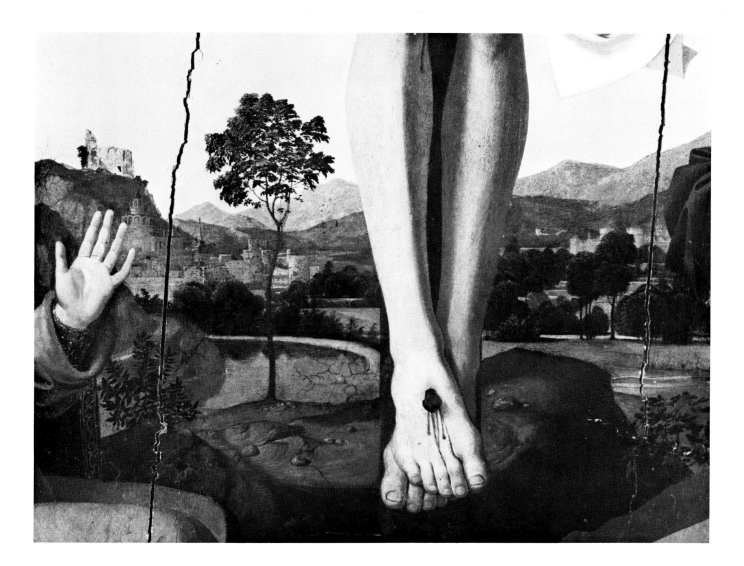

laws of nature very early on. Studies of burial furniture and sarcophagi have shown that the ancient Egyptians and Greeks knew a remarkable amount about wood. Orders for religious panel paintings from medieval artists reveal a similar expertise; the guilds had strict rules governing not only the quality of artistic work but also the selection of panels.

3
Splitting: The support of this painting consists of a number of boards. A slightly oblique joint coming apart has given rise to a split where it met a weak (in this case worm-eaten) point in the wood. The split in the support has fractured the paint layer. Restoring this picture will involve refixing the boards, closing up the splits, filling areas of paint loss (lacunae), and retouching. Lieferinck, *Crucifixion* (Louvre).

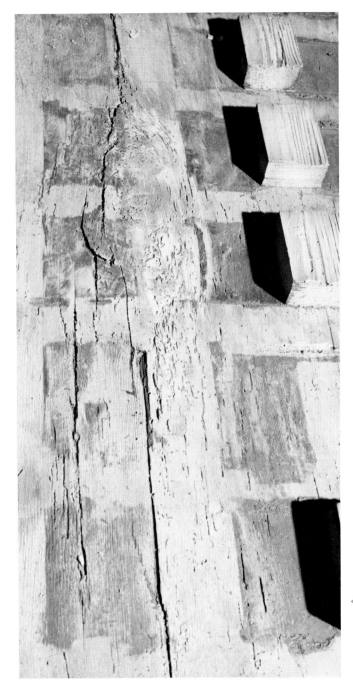

5

Reversed tapering crosspieces: The two slats, dating from a fairly modern restoration, are wider at one end than at the other. They are said to be reversed because on one side of the panel we have the broad end of one and the narrow end of the other. By locking the wood in both directions they have caused it to split. Suitable treatment would be either to replace them or to turn one of them round, adjusting its groove accordingly, so that they were no longer reversed. Bagnacavallo, *Virgin and Child* (Petit Palais, Avignon).

4

◁ *Knot:* The back of a thinned-down panel, showing splits and a knot. The heart of a knot is less affected by changes in relative humidity than the areas around it. This sets up tensions, and a knot may become the starting-point for splits. These splits will be closed up by means of wedge-shaped incisions and inlays. Titian, *Crown of Thorns* (Louvre).

6

Splits caused by a glued frame: Raking light from the right shows the state of the painting as a result of inconsidered treatment of the support. The panel had a tendency to warp; locked from behind, it split.

7

Glued frame: The panel was thinned down at some stage, probably with a view to flattening it, and in order to keep it flat a frame with three cross-grain members was glued to the back. By blocking any play in the wood these caused thin vertical splits to appear – with the consequences that can be seen on the front of the panel. Lorenzo di Credi, *Noli me tangere* (Louvre).

Deterioration: causes and treatment[17]

The causes of deterioration in wooden panels may lie in their constitution, in the natural process of aging, in poor conditions of conservation, or in the efforts of previous restorers, there being few ancient works whose supports have not at some time been tampered with.

The types of deterioration affecting wooden panels are, in ascending order of seriousness:

Camber: A painted panel has, say, acquired a certain camber in the course of time, owing to the fact that the wood has dried out more on one side than on the other (fig. 13). There are two basic causes of this:

1. The way in which the wood was sawn (i.e. lengthways in slabs).
2. Lack of symmetry between a painted recto and a bare verso (panels painted on both sides being seldom cambered).

What this means is that the painted side, where the paint layer forms a kind of humidity barrier,[18] is less subject to climatic variation and consequently to shrinkage than the back, where the wood is in direct contact with the surrounding air. We say that the panel has acquired "curvature" if the camber is more or less the same along AB as along CD. Placed on the flat, it will rest on the two sides AD and BC (fig. 14, ill. 2).

> Since this type of deterioration is the result of the normal process of aging, no attempt should be made to correct it. Either the panel should be left as it is or it should be supported loosely in a frame that follows the camber – in the case of small or medium-sized panel – or, if it is a large panel, by applying to the back compensating crosspieces sliding in cleats. (See the section *Repairs*, pp. 23–30, for a fuller discussion of the treatments outlined here.)

Warping: A panel is said to "warped" or be "out of true" if AB and CD show different cambers. Placed on the flat, the panel will rest only on points A and C or B and D (fig. 15). Warping generally occurs in panels made of irregular wood, i.e. where the boards do not behave in the same way all along the grain. It may also result from over-rapid drying or

9

Worm damage: Detail showing advanced woodworm damage in the sapwood area, which offers less resistance to worm than the mature wood. Disinfection will stop the worms; subsequent impregnation with resin will harden up the worm-eaten portions. Brosamer, *Samson and Delilah* (Louvre).

8

◁ *Splits caused by a fixed cradle:* Both the slats lying along the grain and those lying across it are screwed to the panel. The man who carried out this piece of restoration was ignorant of the way wood behaves; his fixed cradle has had the effect of inhibiting all movement and splits have appeared at top and bottom. The offending cradle will be removed and the splits closed up. The work will then be reinforced with sliding crosspieces known as runners. Master of Burgo de Osma, *St. John the Baptist* (Louvre).

from an ill-considered repair (e.g. a disproportionately heavy cradle fixed to a thin panel).

If warping is the result of aging, no attempt should be made to correct it. If it is the result of an old repair (e.g. a cradle), the repair should be retained as long as it has not made the panel crack or the paint layer lift. If by inhibiting the support it has caused or threatens to cause the paint layer to come away, it should be removed.

Splits and fractures: Splits and fractures may, if they are just beginning, be visible only on the back of a panel. Or they may go right through the panel, attacking and fracturing the paint layer (ill. 3). They may further be characterized on the painted side by a difference in level between the two edges or lips of the split. Splits may be caused by:

1. The lie of the wood, a knot, or a knotty area (ill. 4).

The treatment here consists in gluing cleats across the split or alternatively in making wedge-shaped incisions down either side of the split and lining them with wedge-shaped inlays.

2. Stresses operating against the grain in panels where the play of the wood is inhibited by some element or elements fixed to the back – e.g. crosspieces running against the grain, reversed tapering crosspieces, or a fixed cradle or frame (ills. 5, 6, 7, 8). These may be original or they may date from an earlier repair.

Treatment consists first of all in eliminating the cause of the damage by removing all material that is not original and consolidating the splits. If the cross-grain elements are original one will endeavor to keep them but at the

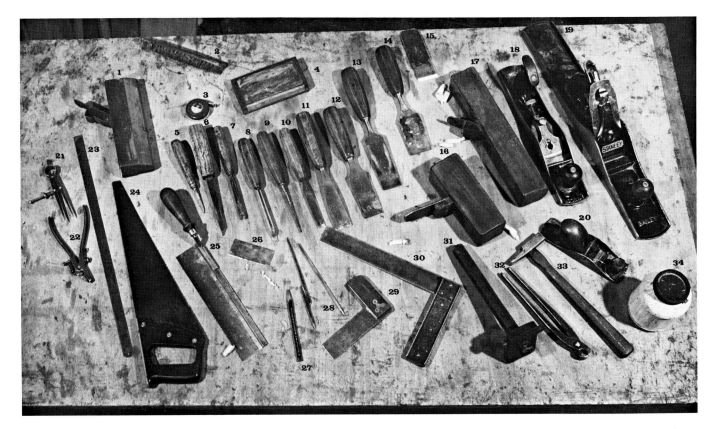

10

The cabinet-maker's tool kit

For sawing: panel saw (24) – tenon saw (25) – setting pliers (22).

For smoothing: trying plane (19) – smoothing plane (18) – round planes (1, 17) – hand plane (20) – tooth plane (16) – plane iron (15) – scraper (26) – whetstone (4).

For marking: squares (29, 30) – marking gauge (31) – scribers (28) – dividers (21) – measuring tape (3) – rule (23) – pencil (27.

For incisions: mortise chisels (5, 6) – gouges (7, 8, 10, 11) – chisels (9, 12, 13, 14).

For assembly: glue (34) – hammer (33) – pincers (32). Brush (2).

same time make them mobile. For example, original crosspieces fixed against the grain will be modified by means of an arrangement of screws in elongated holes, which will allow the wood free play. Reversed tapering crosspieces will be turned round to run the same way.

3. Splits and fractures may also be the result of accidental damage such as a blow received during handling or in transit.

Treatment in this case will be the same as for splits in general.

Joints coming apart: A panel consisting of a number of boards may begin to come apart as the glue fixing the boards together loses its power of adhe-

11
Cleats: To repair two splits in this panel, cleats have been glued to the back. Cleats serve to hold the wood in place after a split has been closed up; they are used in cases where there is no need to level up the lips of the split (which calls for an incision). Van Es, *Still-life* (Louvre).

12
Runners, knots: Original dovetailed runners held in cleats nailed to the support. This is a good example of a well-constructed panel. Knots that would have caused splitting and blistering have been removed in three places and squares of sound wood inlaid. Palmezzano, *Crucifixion* (Petit Palais, Avignon).

sion. This kind of damage may also be provoked by a cross-grain backing element, the joint offering an area of inferior resistance to stress. The damage may only be partial and not have fractured the paint layer along the whole length of the joint.

In this case treatment consists in making wedge-shaped incisions down either side of the split and lining them with wedge-shaped slivers.

When the joint has come apart along its whole length and fractured the paint layer:

The appropriate treatment is to reassemble the joint using the mortise and tenon system.

Biological attack: Mildew damage being unusual in satisfactory conservation conditions, the principal damage under this heading stems in temperate climates from the larvae (known collectively as "woodworm") of the death-watch, Capricorn, and

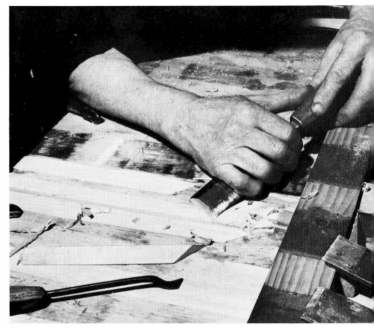

13

◁ *Wedge-shaped inlays, knot:* This poplar panel had been thinned down at some stage. To close up the splits, the lips of which were out of true, the restorer has made wedge-shaped incisions and inlaid short lengths of wood, allowing him to follow the line of the grain. The knot – always a cause of trouble – has been removed and a disc of sound wood inserted in its place. Titian, *Crown of Thorns* (Louvre).

powder-post beetles. These larvae bore tunnels or "galleries" inside the wood and make their presence known by little holes in the surface through which they expel a characteristic dust and from which the adult insect emerges. The soft sapwood and glued areas are the most susceptible to woodworm damage (ill. 9).

Treatment is to disinfect the wood with a suitable insecticide (liquid or gas), following this up if necessary by impregnation to consolidate the affected area.

14
Closing up splits by means of wedge-shaped incisions
Left foreground: elbow-stock chisels.
Right foreground: tooth iron.
The cabinet maker is using a chisel to cut a groove. A wedge-shaped piece of new wood lies ready for insertion. During this operation the painting is held in clamps, one of which is visible on the left. Beyond the incision now being made is an already completed inlay.

Sometimes a panel will be so riddled with worm that the wood is no longer capable of functioning as a support, a state of affairs that constitutes a serious threat to the paint layer.

The requisite treatment here is to thin down the panel and glue it to a so-called "inert support".

Repairs

The recommendations made in this section, which for reasons of space cannot pretend to be exhaustive,[19] are governed by two fundamental provisos. The first concerns climate; the second, quality of workmanship.

Of capital importance as regards the proper preservation of a wooden panel is the stability of the climate in which it (as we have already said) "lives", a relative humidity of 50–60% and a temperature of 18° C (65° F) being the norm. And it should be a golden rule of every restoring studio that no one shall undertake repairs on a painted panel except a first-class specialist cabinet-maker. No amount of sophisticated equipment can ever take the place of experience and manual skill.

Repairs to wooden panels are of two sorts: those that consolidate the original support and those that add external reinforcement of some kind (ill. 10).

1. Repairs to the original support

A split or fracture may have been halted or repaired at some time by means of:
a. Cleats glued across it (ill. 11).

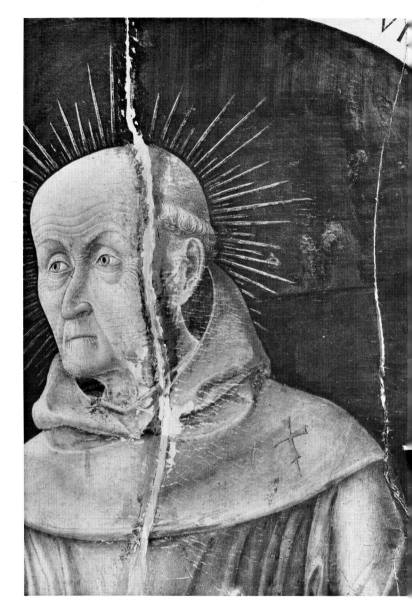

15
Curved splits: These two splits will be closed up from behind by means of wedge-shaped incisions inlaid with wooden wedges cut in short lengths to follow the line of the fracture. Vivarini, *St. John of Capistrano* (Louvre).

16

Mortise and tenon jointing: This sixteenth-century panel consisting of a number of boards had come apart, fracturing the paint layer all along the joint. It is being solidly reassembled by means of mortise (the cavity) and tenon (the projection that fits into it) jointing. After Raphael, *The Virgin of Loreto* (Louvre).

b. Reversed dovetail inlays (figs. 16, 17, ill. 23).

c. Inlays of sound wood in place of knots, which offer starting-points for splits (ills. 4, 12, 13).

d. Rectangular inlays (fig. 18).

The modern method is to inlay wedge-shaped slivers of wood in wedge-shaped grooves. This is an excellent way of closing splits and fractures and particularly of levelling up the lips of a split (fig. 19, ills. 13, 14, 15).[30]

A joint that has come apart along its whole length and fractured the paint layer is reassembled by means of mortise and tenon jointing (ill. 16).

A badly wormeaten panel is disinfected either by painting the back with a volatile liquid (e.g. carbon tetrachloride) or by placing the panel in a sealed chamber that has been emptied of air and filled with gaseous ethylene oxide or methyl bromide.[20]

Panels with serious woodworm damage are nowadays also hardened by impregnating them with acrylic or vinyl resins.[21]

If impregnation is insufficient and the wood is so riddled with worm as to constitute a threat to the paint layer the restorer will employ the treatment known as *thinning down*. Removing everything except the few millimeters of wood that are still sound, he will glue the thinned-down panel to an inert laminated support.[22][23][24] From the eighteenth century to the middle of our own century thinning-down was widely practiced as a method of straightening out curved panels. Nowadays this type of deformation is left uncorrected as testifying to the work's long history.[25][26]

Another method employed in the past to reduce curvature was called *sverzatura* and consisted of making parallel incisions in the back of the panel and filling them with slivers of wood. It was the

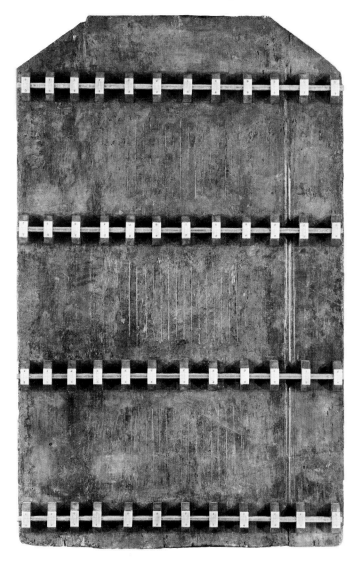

17

Runners; "sverzatura" or straightening: A recent restoration consisted solely in securing the panel by means of runners, which slide inside cleats and allow the wood free play. Also visible is an earlier attempt to correct the warp acquired in the natural process of aging by making linear incisions, spreading the lips apart, and inlaying slivers of wood. Bartolo di Fredi, *Adoration of the Shepherds* (Petit Palais, Avignon).

18

Sliding system: Here a sliding cross-piece was fixed right from the start by means of iron pegs embedded in the panel. The pegs are able to move in elongated holes in the cross-piece, allowing the panel free play. Tiny pins driven through the pegs hold the cross-piece in place, with metal washers to prevent them from digging into it and locking. Cosimo Rosselli, *Annunciation* (Petit Palais, Avignon).

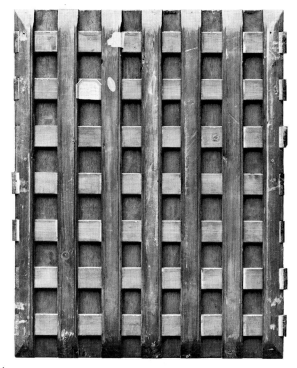

20

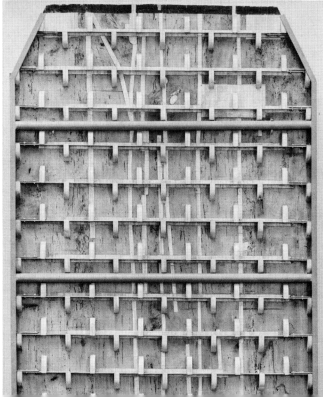

◁ 19

Elongated holes: The original panel had a frame fixed to it. The two uprights lying across the grain had caused splitting, and it became necessary to reassemble frame and panel in such a way as to leave the latter free play. Now the screws driven into the frame are able to slide back and forth in elongated holes cut in the panel. Florence, fifteenth century, *Christ in the Tomb* (Petit Palais, Avignon).

20

Flat moving cradle: The vertical slats are glued with their grain following that of the original wood; the horizontal runners, lying across the grain, slide through slots in the former. This kind of cradle allows the panel free play. Brosamer, *Samson and Delilah* (Louvre).

21

◁ *Runners:* Here the horizontals are square metal rods running in alternating metal-lined half cleats. Again the wood is allowed free play.[30] Sassetta, *Virgin and Child with Angels* (Louvre).

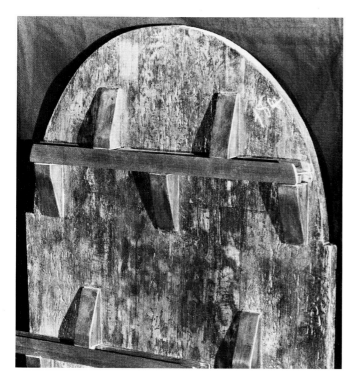

method used by François Hacquin in 1799–1800 to straighten the support of Raphael's *Foligno Madonna* before transferring it (ill. 17).[27]

Transfer, which consists in replacing the original support in order to reach and treat a damaged ground, was practiced constantly and often unnecessarily from the mid-eighteenth century up until the first third of the twentieth century.[28] Nowadays restorers try to preserve a wooden support as being an original part of the work – on the assumption that the future will come up with new and less

22
Runners: These channel-girder runners are held in generously spaced half cleats. The cleats are fitted with little plastic rollers that engage with the inner faces of the channels. This means that the glued surface of the cleats is relatively small and the frictional surface reduced to the two paths along which the rollers run.[33] Florence, fourteenth century, *Virgin and Child* (Petit Palais, Avignon).

23
Reinforcing frame: This one-piece panel of carefully selected ▷ poplar is still as sound as a bell and has hardly a worm-hole in it. One very ancient split was halted at an early stage by means of a simple dovetailed inlay. It was not the progressive type of split, and in view of the panel's otherwise perfect state of preservation no further intervention is called for. A simple surround with four cross-pieces gives support while leaving the panel free to move inside it – a neat and effective solution involving no interference with the panel itself. Leonardo da Vinci, *Mona Lisa* (Louvre).

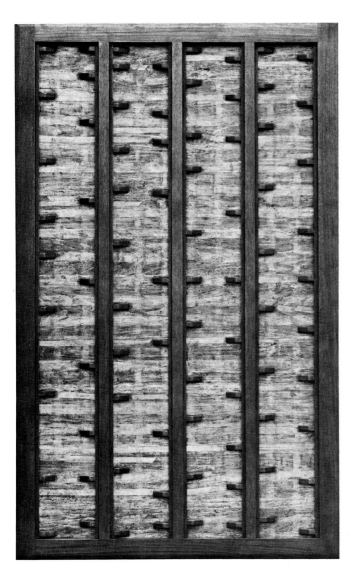

24
Combination frame and cradle: This bakelized wooden frame is of a piece with metal runners that engage with plastic rollers. The system allows the wood free play within the frame while providing essential reinforcement for a panel so thin for its size that it could never have supported itself. Titian, *Crown of Thorns* (Louvre).

irrevocable methods of treating damaged panels without doing away with them entirely.

2. Added reinforcement

There are three classic ways of reinforcing a wooden panel.

The first is by means of *crosspieces,* which may be original or added later, either with a dovetail section sliding in cleats (ill. 12) or in a groove in the panel itself, or sliding with the aid of elongated holes taking pins fixed to the panel (ills. 18, 19). A panel may be fitted with one or a number of crosspieces. When a number of crosspieces are reserved (i.e. lie in opposite directions) they can provoke fractures (ill. 5), each of them blocking the wood in a different direction.

The second way is to use a *cradle.* Again this may be original or a later addition, and its purpose is to keep the panel flat by making it less fragile. This type of reinforcement, when as sometimes it is screwed, glued, or even nailed to the panel, can also provoke fractures (ills. 6, 7, 8).

It was around 1770 that the Paris cabinet-maker and reliner Jean Louis Hacquin (the father of François) perfected the *sliding cradle* – an assembly of fixed slats glued along the grain of the panel and punctuated with slots at regular intervals in which runners lying across the grain are able to slide freely (fig. 20, ill. 20).[29] The sliding cradle enjoyed a great vogue right up until the middle of this century, but a growing awareness of the dangers of classical types of cradle (through the runners becoming blocked as a result of the normal play of the wood

28

25

Frame with back plate: The metal perimeter frame round this panel is screwed to a rigid acrylic plate that backs up the thin support while still allowing it free play. This is an elegant solution requiring no gluing on the original support and leaving all marks and other documentary traces on the back of the panel clearly visible.[34] Venice, sixteenth century, *Portrait of a Man* (Petit Palais, Avignon).

26
Frame with back plate: Another type of frame with a rigid acrylic back plate. If a panel has a tendency to warp it is fitted with retaining cleats; the wood can still move and is at the same time adequately supported. Maestro Esiguo, *St. Michael* (Petit Palais, Avignon).

Two types of metal sliding crosspieces have replaced the old cradles:
a. Stainless steel rods of cylindrical (fig. 21, ill. 17) or rectangular section (ill. 21) sliding in metal-lined wooden cleats.[30] [31]
b. Small metal channel girders engaging with free-wheeling plastic rollers (fig. 22, ill. 22).[32]
The third solution, an original or added *frame* around the panel, allows the latter free play inside a groove. It is the most satisfactory type of reinforcement since it requires no gluing on the panel itself.[33] Fitted with several crosspieces, it will obviate any deformation whatever. The *Mona Lisa* is a good example of this method (ill. 23).
Old types of frame have been perfected and adapted to suit particular cases (ill. 24). One type invented fairly recently consists of a metal perimeter frame fixed to a sheet of polymethyl methacrylate (acrylic), which, being transparent, allows an unimpaired view of the back of the panel. A skilled craftsman can make such a frame follow the curvature of the panel – an elegant and effective minimal solution for small and medium-sized thin panels (ill. 25, 26).[34]
Summing up what is already very much a summary, one can say that the tendency in panel restoration has been towards a minimalist position as regards repairs to the panel itself[35] and towards reducing areas of friction and glued areas as far as adding external reinforcement is concerned.

and so causing splits) has steered modern research in the direction of reducing glued areas and areas of friction.

CANVAS

Introduction[36]

Canvas was first used as a support for painting back in Hellenistic Egypt. In the Middle Ages it was often used in conjunction with wooden panels, where it is invisibly "drowned" in the thick layer of ground that was used to prepare such panels for painting. With the Renaissance, canvas came to be used as a support in its own right, largely replacing wood. The first canvases were primed with a very thin coat of paint that was almost a dye; this was the case with the earliest banners painted on both sides and with the *telae Rense* or "Reims canvases" (a finely-woven linen canvas) used by Bellini, Mantegna, and Dürer. In Western painting canvas can be said to have been in general use as a support by about 1500, though of course its heyday was in the eighteenth and nineteenth centuries.

It was in Venice that artists first began to use canvas extensively; they found that it took oil paint better than a wooden support. Venetian painters of the sixteenth century used heavy herringbone canvases for their works, as we see from Veronese's *Marriage at Cana* (Louvre). Seventeenth-century Italian artists preferred a loose hemp canvas, while in France and northern Europe most painters used tightly-woven linen canvases, which in the eighteenth and nineteenth centuries became steadily finer and denser as machine-weaving became more and more sophisticated. By the nineteenth century there was a wide range of canvases available and artists were able to achieve smooth, shiny finishes and subtle effects. In more modern times artists have tended to use cheap, mass-produced textiles as well as exploiting the fresh possibilities opened up by synthetic fibres.

How did canvas come to be used in the first place and what made it so popular?

There were three main reasons – a technical one, an economic one, and an artistic one. From the purely technical point of view canvas made it possible to paint large works without running into a weight problem, a canvas altarpiece being of course very much lighter than the traditional wooden polyptych. Secondly, a canvas support was less expensive than a panel or for that matter a tapestry. And thirdly there was an artistic reason: the flexibility of canvas as well as its distinctive texture encouraged artists to look for and achieve new effects, the rigid contours of a Bellini for example giving way to the flowing lines of a Tintoretto.

Conservation

The basic thing to remember here is that a piece of canvas that has been sized and covered with a ground and a layer of paint does not behave in quite the same way as a piece of raw canvas.

The point of sizing the canvas is to ensure good adhesion between the ground and its support and to slow down the process of oxidation affecting the material on contact with the oils in the ground. It reduces the extent to which the canvas will shrink and expand – without anyone even today knowing quite how it does so. Canvas and size form a hygroscopic whole, i.e. one that is sensitive to

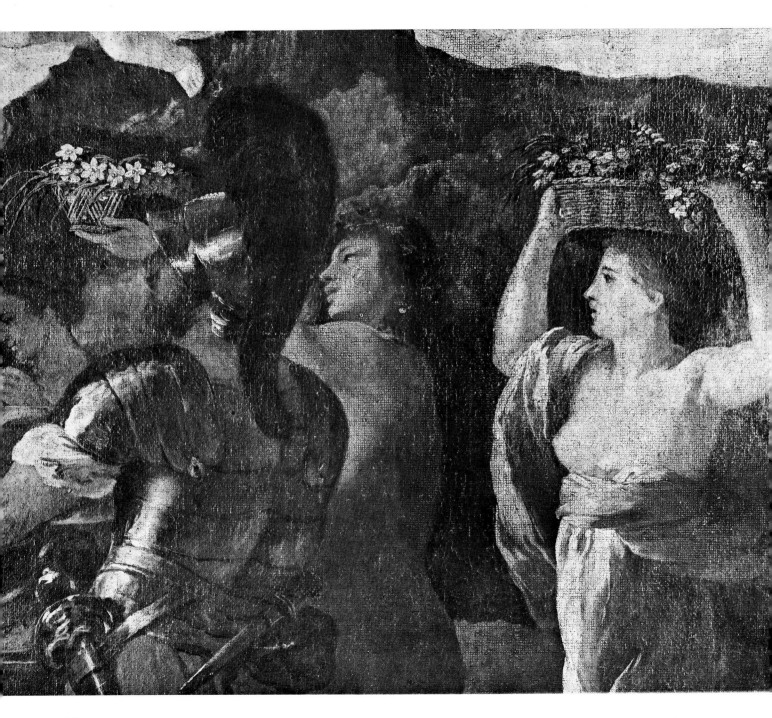

changes in the relative humidity; ground and paint layer on the other hand form a fairly inflexible mass. The result is that the two sides of the painting react differently to the ambient climate. The inert ground and paint layer are subjected to stresses arising out of the alternate swelling and shrinking of the canvas, which besides weakening the latter can, if the ground is no longer flexible enough to absorb it, cause the phenomenon known as "craquelure", visible as a minute crazy-paving pattern on the surface of the painting. This is the first indication that the ground and the paint layer are beginning to come away from the support.

So climate is as important a factor in the conservation of canvas paintings as it is in that of wooden panels, and the chief prophylactic measure is to *avoid climatic variations*, which cause canvas "fatigue", promote biological attack, and fracture the ground into a network of tiny cracks that will eventually make the paint lift.[37] The ideal climate for paintings on canvas supports is a relative humidity of between 50 and 55% and a temperature of 18° C (65° F).

Because of the climate problem the question of applying protective screens or humidity barriers to the backs of paintings has been a constant preoccupation of restorers since the eighteenth century. Various solutions have been tried.

One was to line the original canvas with a sheet of unsized canvas, as was done with the large Romantic ruin-paintings by Hubert Robert in the Louvre (*The Maison Carré at Nîmes, The Pont du Gard, The Triumphal Arch at Orange,* and *Inside the Temple of Diana at Nîmes*).

Another method experimented with was to back the painting with thin sheet metal, a method of which the National Gallery of Arts in Washington D.C. apparently has a century-old example.[38] Unfortunately there is a risk of condensation forming on the metal following a sudden drop in temperature.

Occasionally a plastic backing has been used, the idea being to create a micro-climate. Here it is important to make sure that no damp gets sealed in; unable to evaporate, it will soon encourage mildew.

Finally, a method widely used in the seventeenth and eighteenth centuries was to impregnate the back of the original canvas with, basically, oil or a mixture of wax and rosin. Such impregnations have been responsible for protecting many paintings kept in damp surroundings, but they had their disadvantages: paintings on their original canvas tended to become brittle and liable to tear; relined paintings tended to suffer from lifting of the paint layer as a result of sealed-in moisture.

The second way of preventing deterioration in a painting on a canvas support is to *avoid vibrating the canvas* during handling and in transit, because vibration can do as much damage as the play caused by climatic variation. The growing popularity of travelling exhibitions is undoubtedly taking years off the lives of the works that get carted around.

The third preventive measure is to *avoid boosting oxidation* of the canvas by protecting it as far as possible against air pollution, by not applying oily

27
"Pavement" canvas structure: This picture was painted on loose fabric; the canvas weave shows through in a pattern of little squares of paint known as "pavement" structure. Poussin, *Triumph of Flora*, detail (Louvre).

substances directly to the verso, and by keeping it away from very bright light with its high proportion of ultra-violet rays.

Repairs

The two main types of repair that have been made to canvas paintings since the seventeenth and eighteenth centuries are relining and transfer.

1. Relining

Relining, a widely-used method of conservation, consists in gluing a new piece of canvas to the back of the original canvas with the aid of an adhesive (see fig. 24).

The point of relining is to strengthen a torn or damaged canvas support or one that has simply become too weak to fulfill its function; it may for example have deteriorated to the point where it is no longer capable of supporting a heavy impasto paint layer, or a previous relining job may need renewing, or the edges of the canvas may be in bad shape. Relining also makes it possible either to re-establish adhesion between ground and support by renewing the size layer or to flatten any distortion of the painted surface due to poor storage conditions (i.e. when paintings have been rolled up or folded), to stretcher marks, or to craquelure causing the paint layer to lift.

The requirements of a satisfactory relining job are that it should not alter the color of a painting, its surface texture (i.e. it should not flatten the impasto, or the flexibility of the support; at the same time

28

"Pavement" canvas structure: Detail of the "pavement" structure caused by the weave of a loose canvas appearing in relief. Varnish and dirt have collected in the cracks to form a grid of brown lines following the threads of the fabric. Poussin, *Bacchanalia,* detail (Louvre).

it should be characterized by thorough penetration of the adhesive employed and it should respect one of the rules of modern restoration, namely reversibility (i.e. it should be possible to redo it without damaging the ground and paint layer). Reversibility in the strict sense is difficult to achieve, however,

because relining always implies a material modification of the work.

The different types of relining fall into three groups depending on whether glue, wax, or a synthetic resin are used as the adhesive. Each has its fans, who of course swear by nothing else. Let us just say that the dogmatic approach should be avoided and one's choice of method be governed by the case in hand, by the local climate (humid countries, for example, have generally adopted wax), and by one's own experience. We do not propose here to go into the details of each method but rather to make a rapid survey of the history, advantages, and disadvantages of the principal types of adhesive usee for relining purposes. Researches conducted in various parts of the world[39] have come up with everything from using mixed adhesives (wax and glue) to trying out modern synthetic resins, cutting down or even abandoning the use of heat and pressure, and finally the extreme position of refusing to reline at all in certain cases.[40]

a. Relining with glue

There are several traditions here, among them a French tradition, which uses linen canvas, paste,[41] and a smoothing iron, with tracing-paper replacing heavy pressure; an Italian tradition using hemp canvas, a special paste or *colletta*,[42] and, for pressure, a wooden roller that was later replaced by the smoothing iron; a Russian tradition, in which sturgeon glue is used in conjunction with a smoothing iron;[43] and a Japanese tradition, in which works painted on paper are lined with sheets of Japanese vellum glued with fresh or matured starch paste.[44]

Relining with glue must have originated in the seventeenth century. It was widely practiced in the eighteenth century and is described by several authors.[45] Paris restorers got onto it very early, and an inventory of the paintings in the French royal collections drawn up by Bailly in 1709–10 mentions numerous relinings, many of them carried out in order to adjust the format of a work. Fairly rough and ready in the early days, the technique was improved by the Hacquins (father and son), who together with their successors the Fouques (another father and son team), looked after the French royal collections until the middle of the nineteenth century. They were particularly busy of course at the time of the Napoleonic conquests, when paintings came flooding into Paris from Belgium, Holland, and Italy. The most important paintings in Europe passed through their hands, and those Paris reliners acquired a vast body of experience that has been passed from father to son and from master to apprentice right down to our own day. A good deal of glue relining was done in Edwards's studio in Venice (see p. 9) as well as in other countries. It is an operation calling for much experience and one that can only be learned in a restoring studio with a long tradition behind it.

The *advantages* of relining with glue can be listed as follows:

Powerful adhesion

Effective reabsorption of craquelure and distortions of the paint layer that have stiffened (the glue will make them flexible again)

No change in color (i.e. it does not alter the reflective power of the ground)

No change in brilliancy (i.e. a mat painting stays mat)

Reversibility (relinings done a hundred years ago

35

can easily be redone today, glue being a compatible material with the original size)

Its *disadvantages* are:

The introduction of damp, with the consequent risk of spontaneous transfer if the material shrinks (i.e. special precautions have to be taken)

Risk of mildew in a humid environment

The slight hygrometric play of the new canvas and glue may subject the original ground to fresh stresses

Glue tends to lose adhesion and become brittle with age (a good glue relining job will usually need redoing after a hundred years)

b. Relining with wax

This is the so-called "Dutch" method that first became current in the nineteenth century but must date back to the eighteenth. The adhesive used here is a mixture of wax (for adhesion) and resin (to give an element of rigidity and raise the melting point) and it is made to penetrate either with the aid of a hot iron or by placing the painting in a flexible envelope, laying it on a hotplate, and subjecting it to a vacuum.[46] Instead of natural wax and resin many studios now use microcrystalline petroleum wax and various synthetic resins. The technique of wax relining appears to have been born of the restorer's constant concern to protect paintings from damp and to have been directly stimulated by a book on encaustic and wax painting published by the Comte de Caylus in 1755 (see p. 46).[66] It was performed on Rembrandt's *Night Watch* (Rijksmuseum, Amsterdam) by the Dutch restorer Hopman in 1851,[47] and since then the technique has undergone progressive improvement in a number of countries, with variations from studio to studio.

Advantages:

No introduction of damp (and consequently no risk of transfer if the material shrinks)

No risk of mildew

Very little hygrometric play

Permanent adhesion

Disadvantages:

Inferior reabsorption of craquelure as compared with glue (wax will not restore flexibility to the original ground; it can only arrest the process of deterioration at a given moment)

Risk of color alteration (a white ground impregnated with wax may become more translucent and consequently less reflective, and wax relining is out of the question for paintings using distemper, gouache, tempera, and even certain oil paints that cover irregularly.[48]

Makes the ground and paint layer more vulnerable to chemical agents (solvents) and to rubbing, etc.

Not strictly reversible (i.e. the lining canvas can be removed by the simple application of heat but it is impossible to get rid of all the adhesive, since it penetrates the fibres of the original canvas; a wax relining job can only ever be redone with wax)

c. Relining with synthetic resins

Invented around 1930 and significantly improved some twenty years later, this method makes use of

29

Herringbone canvas: The structure of this twill-woven canvas has become visible on the front of the painting as varnish and dirt have accumulated in the cracks. Philippe de Champaigne, *Last Supper*, detail (Louvre).

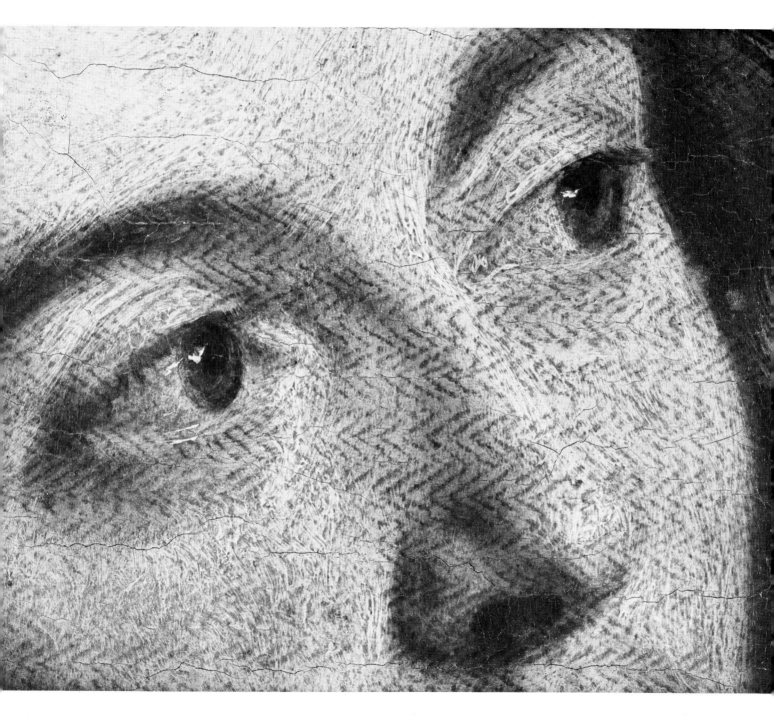

thermoplastic adhesives (usually vinyl or acrylic resins) in one of two ways. In the first the picture is simply lined with a piece of canvas coated with adhesive; gentle heating softens the surface of the adhesive and makes it stick. This process has been extensively used for reinforcing flags.[49] A recent variant known as "nap bond lining"[50] is performed cold and is particularly suitable for strengthening pictures with very little ground (décors, hangings) or painted on highly reactive unsteamed canvases that are without serious distortion, craquelure, or other damage to the paint layer. The second use of the method is to combine actual relining with deep penetration or impregnation of the original ground with the synthetic adhesive.

Advantages:

Little or no introduction of damp, depending on the material used (consequently little or no risk of transfer)

Good resistance to hygrometric variation

Little risk of mildew

Does not alter the color of the paint layer

Disadvantages:

(in the case of simple lining) Strict reversibility not entirely assured; in other words the new material can be removed easily enough but there is some risk, depending on the method employed, of leaving adhesive behind

(in the case of impregnation) The adhesive is not only impossible to remove (i.e. irreversible); it is also different in kind from the original materials

30

Damasked canvas: The structure of the canvas support – in this case a damask weave characterized by a repeated pattern of diamonds – has become visible through the paint layer. Il Domenichino, *Erminia and the Shepherds* (Louvre).

and there is a risk of setting up tensions between it and the ground

(in both cases) Only partial reabsorption of craquelure and distortions.

Let it be said in conclusion that relining is an operation of capital importance in the life of a painting whichever method is employed, and that the choice of that method should be governed by the structure of the work concerned.

2. Transfer

The operation known as transfer consists in replacing the original support with a new one, and it is of course irreversible.

The point of transfer being to re-establish adhesion between the paint layer and its support when the ground has begun to break up and go powdery (fig. 26), it is necessary to destroy the original support in order to be able to get at the ground and partially or wholly renew it, depending on how bad a state it is in.

The essential requirement of transfer is that it should leave the surface of the painting unaffected. Nowadays most museum restoring studios have given up transferring panel paintings, but the occasional canvas-to-canvas transfer is still performed when refixing and relining are insufficient to restore a badly damaged ground. The wax school do not transfer even then, preferring what they call

31
Serge canvas: The diagonals of this serge weave have formed cracks in the paint layer that accumulated varnish and dirt make obtrusively visible. Reynolds, *Master Hare*, detail (Louvre).

"impregnation in depth", which means positively drenching the painting in wax.

Transfer was the big technical breakthrough of the early eighteenth century. Originating in Italy, it possibly spread to France via Brussels. It was in 1749–50 that Robert Picault performed his celebrated transfer of one of the treasures of the French royal collection, namely Andrea del Sarto's *Charity* (Louvre).[51] The job made Picault's name, and he was showered with honors and wealth. But his excessive financial demands, his refusal to give away his "secret", and one or two failures eventually cost him his position, and he was replaced as official restorer to the French royal collection by craftsmen of a more modest and less secretive stamp (Godefroid, the Hacquins, and the Fouques). The keepers of the royal collection and, from 1793, the administrators of the Louvre Museum preferred to know what was being done to the paintings in their charge. The transfer of Raphael's *Foligno Madonna* (Vatican Museum) by Hacquin *fils* in 1799–1800 was a major event in the history of the process.[52] Thereafter the fame of the Hacquins spread far beyond the frontiers of France, and Polish collectors used to send their paintings to Paris to be transferred by them.

Not only in Europe but also in Russia, where Ivan Siderov and his sons transferred four hundred paintings at the Leningrad Hermitage in the latter half of the nineteenth century,[53] transfer continued to be regarded as a kind of miracle treatment throughout the nineteenth and the first third of the twentieth centuries. It was undoubtedly overdone, but on the other hand it was probably responsible for preserving into our own day pictures that would otherwise never have survived. Since about 1930, however, there has been an increasing tendency to regard the support as an integral part of the work and consequently to preserve the original as long as anyhow possible.

An alternative method in the case of loosely-woven canvases is to refix from behind by passing glue through the back of the canvas, following this up with relining; if the ground has not deteriorated too far it is thus possible to re-establish adhesion between paint layer and support without having to destroy the latter. Or if the canvas is too dense to allow the glue to pass through, the restorer can thin it down from behind in the process known as "semi-transfer".

The restorer only resorts to the extreme of full transfer when there is an acute danger of losing a painting unless something is done and transfer appears to offer the only solution.

THE PICTURE LAYER

Before turning our attention to the types of deterioration that can affect the picture layer, let us take a quick look at the elements of which it is made up. These are – in the order in which they are applied to the support – the ground, the paint layer, and the varnish layer (fig. 25).

The ground[54]

This is a layer of matter applied to the support in order to protect it and prepare it to take the paint. In a finished painting the ground is usually covered up, but there are various ways in which we may know or discover its nature:
- from contemporary textual sources;[55]
- when the paint layer has flaked or lifted;
- when a painting is being transferred to a new support and the ground is exposed from behind;
- when the edges of a canvas or panel have been prepared with ground but left unpainted;
- by modern methods of analysis.[56]

Actually the ground itself consists of a number of layers: a sizing coat of rabbit-skin or casein glue applied directly to the support, then the ground proper, and in some cases a priming coat or *imprimitura,* the object of which is to create a uniform surface, reduce porosity, and possibly modify the color of the paint to be laid on top of it.

The thickness of the ground varies. Fourteenth and fifteenth-century Italian panels have a thick ground, sixteenth and seventeenth-century Flemish panels a thin one; sometimes, for example with some of Van Goyen's translucent grounds, the pattern of the grain even shows through.

The role of the ground is primarily mechanical. Its most essential function is to provide good adhesion between support and paint layer while at the same time insulating both elements to prevent them from interacting with and damaging each other. It further makes the support smoother to paint on.

It also plays an optical role, however, in so far as it constitutes a reflecting surface whose color will affect the harmony of the finished work.

The white grounds of their panels lent tremendous luminosity to the distemper paintings of the Primi-

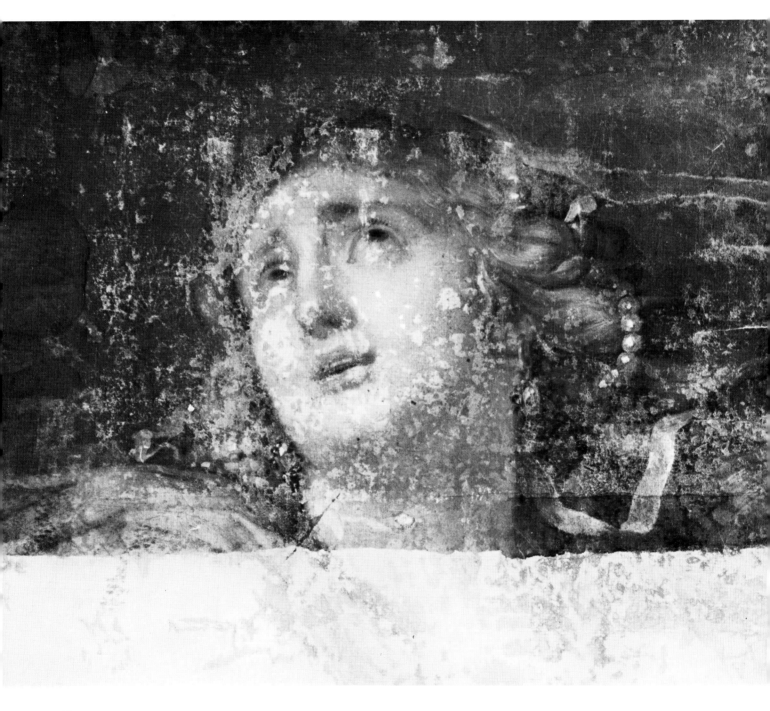

tives – and even greater luminosity to such translucent paintings as Rubens's *Virgin with Angels* (Louvre.

Between the mid-sixteenth and eighteenth centuries white grounds were largely abandoned in favor of tinted, usually dark preparations, one of the characteristics of which is their tendency to show through with the years as the superimposed paint gradually loses its covering power.[57]

Poussin, a stickler for technique, would be shocked to discover how his *Moses Changing Aaron's Rod into a Serpent* (Louvre) has darkened as a result of a black primer having been applied to a colored ground.[58] Murillo's *Angels' Kitchen* (Louvre), with its thin paint layer applied to a thick brown ground consisting of a mixture of resin, bitumen, and white lead, now gives a generally sombre impression. And there are many other examples. This kind of thing is irreversible, and there is no way in which the process can even be arrested.

In the eighteenth century grounds took on a wide variety of colors. Red predominated, but pink ochres appeared in the work of Coypel, Desportes, and Oudry, while Boucher favoured plain pink.

White grounds came back in the nineteenth century with Neo-Classicism. David, for example, in his unfinished *Portrait of Madame Récamier* (Louvre),

brings out his underlying white by means of scumbles.[59] They were also used by the Impressionists, and as the century wore on the mass production of painting canvases already prepared with white grounds spread for commercial reasons.

What we have called the "ground proper" consists of two elements – a medium, and a solid, inert charge – that vary from place to place and from century to century.

Northern and central European painters of the fifteenth and sixteenth centuries prepared their panels with a water-soluble rabbit-skin or casein glue[60] mixed with finely-powdered chalk or whiting. Thinly applied, this type of ground occurs frequently in the works of Memling, Holbein, Rubens, Rembrandt, etc.

Water-soluble glue mixed with calcium sulphate or gypsum formed the type of ground known as *gesso*, with which the Mediterranean schools prepared their panels from the fourteenth century onwards. Many painters embedded a fine canvas in such a ground in order to insulate the paint layer against faults in the wood and reduce the effects of play in the latter.

An oil medium appeared as early as the fifteenth century and spread with the increasing use of canvas supports. It made a flexible ground that was better suited to large-scale canvases subject to climatic variation than the more brittle *gesso* and whiting types. It was taken up by the sixteenth-century Venetians, who progressively abandoned the use of *gesso*, though Rubens, Titian, and Veronese all painted on both types of ground. The oil was usually mixed with white lead (lead carbonate or red lead (lead tetroxide) and various earth pigments (yellow ochres, red ochres, etc.). The

32
Cleavage: The lower part shows varnish that has become opaque and lost adhesion (flaky areas, dark patches) as a consequence of relining. The upper part shows the furbished varnish, and the areas that have lost adhesion appear as light patches. The opaque varnish has been given back its transparency without being thinned down. Thinning-down belongs to the next operation, namely reducing the depth of the varnish layer. Le Brun, *Mary Magdalen* (Louvre).

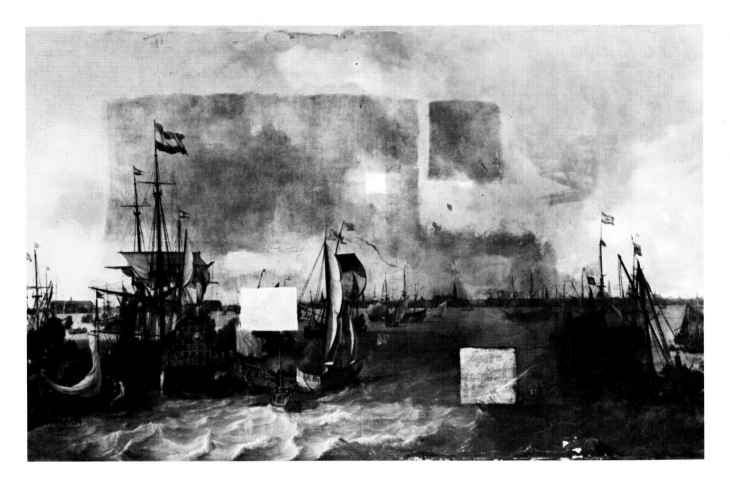

33
Work in progress on treating bloom and reducing the depth of the varnish layer: Opaque varnish has been furbished on the whole of the painting with the exception of three rectangles, which appear light and still opaque. The volume of varnish has been partially reduced at the top and sides of the sky; the middle portion still has the dark varnish. Backhuysen, *The Port of Amsterdam* (Louvre).

mixture took a very long time to dry, so that drying agents were added – often to excess, with disastrous consequences for the painting concerned in terms of darkening, crackling, and so on.[61] Nowadays painters often use chemical grounds based on polymer resins that give them enormous technical scope.[62]

The paint layer

The principal optical element of a painting consists of a colored powder known as "pigment" and a liquid medium that carries, moistens, and binds the particles of color. Pigments may be of animal, vegetable, or mineral origin or they may be the

product of chemical reactions. Man's use of colored pigments goes back to prehistoric times. By the fifteenth century, if we are to believe C. Cennini, painters had a palette of seven basic colors derived from various pigments, though of course mixture and superposition opened up much wider possibilities.[63] Advances in chemistry since the early eighteenth century have considerably increased the number of pigments available to painters. Finding a particular pigment in a painting may in fact help to date it. A work containing Prussian blue, for example, is certain to be post-1704, when that pigment was first synthesized.

Mediums must above all be distinguished by two qualities: they must not modify the color of the pigment, and they must combine with the latter to form an elastic mass. There are several types of medium:

A water-soluble glue, gum arabic, or casein medium mixed with colored pigments constitutes the mat distemper used in illuminations, theater sets, etc.

An intermediate medium consisting of egg emulsion (using the white or the yolk or a mixture of both) forms the basis of the highly stable, tough *tempera* paint used by the Primitives. There were many different recipes for egg *tempera,* some of them involving the addition of oil or resin.

Transparent paint uses an oil medium. The Italian Primitives were using oil mediums for their glazes as early as the thirteenth century.[64] Around the beginning of the fifteenth century they passed into general use, starting with the northern schools. In this connection a great deal of ink has already been spilled on the subject of the so-called "Flemish

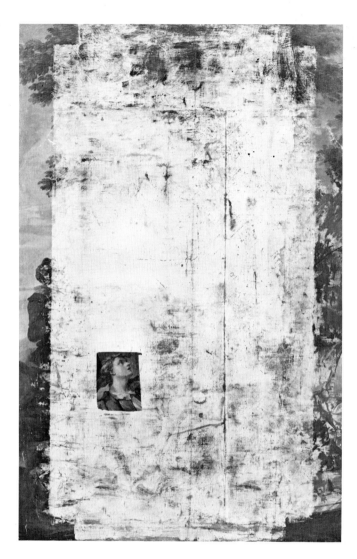

34
Bloom: This painting was mounted in some panelling. When it was taken out for relining the edges that had been protected from the light and from successive applications of varnish were found to be not as badly obscured by bloom as the centre of the picture. One small rectangle has already been furbished, revealing a head. Natoire, *Don Quixote and the Knight of the Mirrors* (Musée National du Château de Compiègne).

technique" or "secret of the Van Eycks'," and there is no doubt plenty more to come.[65]

Laboratory analyses have shown that such painters as Titian and Tintoretto, for example, sketched out their paintings in *tempera* and finished them with an oil-resin medium.

Oil is a slow-drying medium, and painters often added drying agents to speed up the process. As we saw in connection with ground mediums, when used to excess these had disastrous effects on the quality of the paint.[61] The practice spread above all during the eighteenth and nineteenth centuries, when it was frequently abused; Chardin and Boucher were both familiar with it.

Mediums using wax either on its own or mixed with resin or occasionally egg emulsion are remarkably stable and have been in use since antiquity, e.g. in Egyptian sarcophagus paintings, the Fayyum portraits, Byzantine icons, etc. There was a revival of encaustic wax painting, as it was called, in the Neo-Classical period inspired by the excavations at Pompeii and a book on the subject published by the Comte de Caylus in 1755.[66]

Synthetic mediums opened up a new era in painting some fifty years ago in the wake of Max Doerner's experiments with emulsions produced by chemical synthesis.[67] Synthetic resins have made great strides since then, and vinyl, acrylic, and glycerophthalic emulsions are much used by modern painters.

Structurally, the paint layer will vary according to the mode of expression of the artist concerned. It may consist of a single coat – the technique known as *alla prima* used by Rubens for his sketches and by many painters today – but more often it is made up of a number of superposed layers ranging from thin monochrome washes laying down the composition of the work through intermediate layers to heavy *impasto* applications in relief, glazes and scumbles to qualify or intensify other colors,[68] and a top coat or "exudate" containing a high proportion of medium.[69]

The varnish layer

The function of the final coat of varnish applied to a finished painting is twofold: optically it gives the paint layer maximum brightness while at the same time physically protecting it against scratching, dust deposits, and ultra-violet rays. Hated by some painters, it was yet considered a necessary evil. It consists of a resin dissolved in a suitable agent for the purposes of application.

Varnishes have been divided into two classes: soft varnishes, using soft resins (the most common being mastic and dammar) usually dissolved in turpentine,[70] and hard varnishes incorporating hard, tough resins (two well-known combinations being copal dissolved in oil and amber dissolved in oil).[71]

35
Deciding how much varnish to remove: This painting is covered with a thick layer of yellowed varnish. The light vertical stripe is where the varnish has been partially removed; in the even lighter horizontal stripe it has been removed completely. Partial removal recovers colour contrast while at the same time leaving the picture its patina. Spada, *The Prodigal Son*, detail (Louvre).

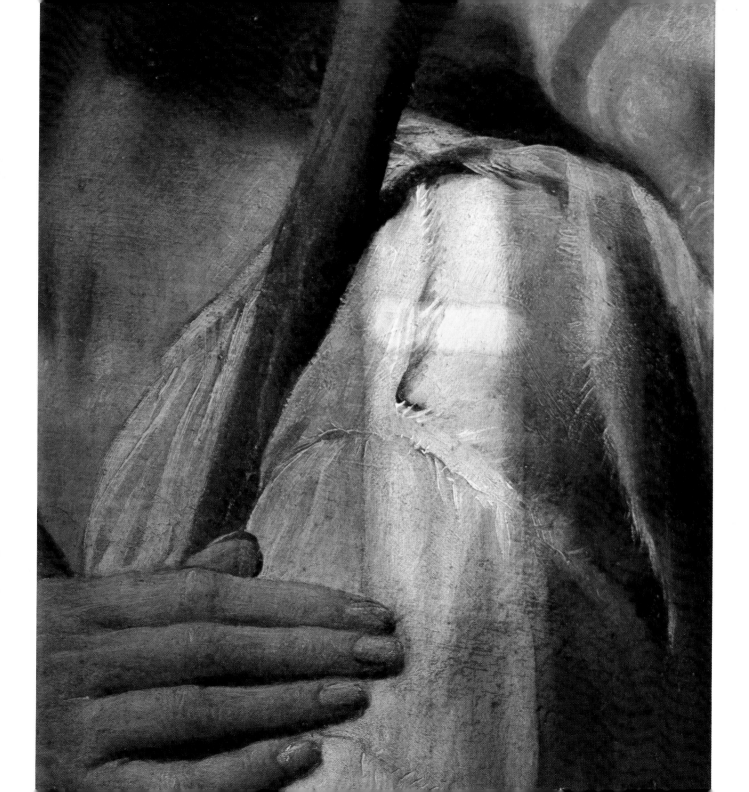

48

At one stage soft varnishes and hard varnishes were very much in competition. In the long run soft varnishes can be said to have had the better of it, with mastic resin apparently being used more often than any other kind.[72]

At times this final varnish layer has been artificially tinted, for example to give paintings that golden glow so much admired in the Age of Romanticism; occasionally varnishes have been waxed to make them less shiny.

In addition to the traditional types of varnish, modern painters now use a variety of synthetic varnishes based on vinyl or acrylic resins dissolved in mixtures of toluene, xylene, etc.[73]

DETERIORATION: CAUSES AND TREATMENT

Following our usual method, we shall here be looking at the types of deterioration affecting the three elements of the picture layer – ground, paint layer, and varnish layer – in order to establish what causes them and suggest how they should be treat-

ed; a more detailed study of those treatments is reserved for the next section.[17]

This time we proceed in the reverse order. We are now looking at the painting from the point of view of the restorer, and the first element that he encounters is the varnish layer.

The varnish layer

The varnish layer may present one or more of the following symptoms:

a whitish look: the varnish layer is covered with a superficial dust deposit as a result of poor conditions of conservation.

The appropriate treatment here is to dust the picture.

a bluish look: Variations in atmospheric conditions have caused the surface of the varnish layer to deteriorate, giving the painting a clouded appearance.

The surface needs to be lightly polished.

dirt deposits, due to the presence of greasy dust in the atmosphere.

The surface of the varnish layer needs to be wiped with a special solution.

bloom: Micro-fissuring has robbed the varnish of its transparency (ill. 36). This type of deterioration is caused by damp and may indicate poor conservation conditions. It often occurs after a picture with a thick varnish layer has been relined with glue.[85] It is not usually as serious as it looks,

36
Bloom: This dramatic painting has suffered only superficial damage from running water mixed with plaster, which has left a white deposit on the surface and caused bloom in the varnish layer. Cleaning has been begun at bottom right to remove this deposit; the varnish will then be furbished and given back its transparency. Between them these two simple operations will make the composition legible once more. Beaume, *Anne of Austria at the Val de Grâce Convent* (Louvre).

even though the painting may be completely obscured by an opaque whitish film.

Bloom is treated by reconditioning the varnish layer (ill. 34).

flouring, a powdery condition often affecting old varnish layers that have already been thinned down. It is due to loss of adhesion between the varnish ingredients.

This condition calls for partial or complete removal of the varnish layer.

local loss of brilliance, caused by a porous underlayer having absorbed the varnish at this point.

The area affected needs to be lightly revarnished.

accidental scratches, due to poor conservation conditions, and

holes in the varnish layer where the varnish has failed to adhere to the paint layer. Fragments of varnish may for example come away with the cardboard at the end of the glue relining process.

The treatment in both cases is to try and compensate by carrying varnish from a part of the picture where it is plentiful to the part where it is scratched or has come away. If this is impossible it will be necessary to reduce the varnish layer, taking the damaged areas as point of reference. If the damage affects the whole thickness of the varnish layer it may be necessary to remove this completely.

darkening: An original or subsequent varnish layer or layers may have yellowed to a greater or lesser extent, distorting the colors and values of the paint layer. This may be due to the natural process of aging (i.e. a change in the chemical structure of the varnish) or to the deliberate addition of coloring matter to the varnish by the painter himself or by a restorer in order to give the picture a yellow glow.

No treatment is called for if the varnish has only very slightly yellowed with age or if the color was added by the painter himself. If the varnish layer is very yellow or has darkened irregularly it will need to be reduced (ill. 37).

streaking: Usually as a result of irregular varnishing or revarnishing the varnish layer is thicker in some places than in others, and where it is thicker it also appears more yellow.

Here again the treatment is to compensate by carrying varnish from the thicker, yellower areas to the areas that are clearest. Sometimes it will be necessary to scrape the edges of dark streaks by hand, i.e. when they cannot be softened chemically without affecting the surrounding areas.

craquelure: This may take the form either of a superficial crazing of the varnish layer due to the normal process of aging or of premature fissuring due to the varnish having dried badly (e.g. as a result of the addition of bituminous matter, a frequent practice in the nineteenth century;[78] ills. 46, 47).

37
During varnish removal: Here we see the three stages of varnish removal: the dark brown of the original varnish, partial removal, and a small square on the right where the varnish has been removed completely. The restorer will settle for partial removal, preserving the picture's patina. From the warm tones of the foreground to the cooler bluish-greys in the distance, the picture has recovered its successive planes; the darkened varnish gave the impression of a landscape without depth. Berchem, *Landscape*, detail (Louvre).

51

Natural aging does not call for treatment. If craquelure is due to a poor job of restoration the re-restorer will try to reduce the offending varnish layer to the level of the uncrazed varnish below. If the varnish layer cannot be treated in this way it will have to be removed.

The paint layer

The symptoms of deterioration that the paint layer may present are as follows:

discoloration of the pigment: This is usually due to ultra-violet radiation, which breaks down the basic colors of organic pigments (e.g. a weak madder lake will become steadily paler).

There is no treatment for this type of deterioration.

growing transparency, revealing for example the grain of a wooden support, the ground (which if dark will affect the overall harmony of the work accordingly; cf. p. 41), or *pentimenti,* sketched or finished details that the artist subsequently thought better of and painted over without having adequately reprepared his ground. All three phenomena are due to natural aging.[57]

Whether the support has begun to show through (e.g. the grain on Dutch panels — Mostaert in the sixteenth century, Van Goyen in the seventeenth) or a dark ground has deepened the overall harmony of the work (e.g. in paintings by Caravaggio, Poussin, Ribera, etc., the development is irreversible and no treatment can stop it. Moreover it usually does not impair the work's appearance. A *pentimento* that does not prejudice one's reading of the work (ill. 45) should also be regarded as an irreversible development not calling for treatment. (A good example is the third leg of Gros's *Comte Fournier Sarlovèze* in the Louvre. If the *pentimento* or underlying composition bears no relation to the final work and disturbs one's reading of the latter it can be broken up by means of a few transparent local retouches. A *pentimento* appearing in the form of patches, however (the edges of Corot's *Chartres Cathedral,* also in the Louvre), is an irreversible development and nothing can be done about it.

bloom: Bloom in the paint layer is probably due either to interaction between pigments and medium or to micro-fissuring of the medium. Examples are to be found in the blue-green color areas of all schools, particularly in the seventeenth

38
During varnish removal: Here a sample of the yellowed varnish has been left (centre). The craquelure visible on this picture is typical of a canvas support. Boucher, *Renaud and Armide* (Louvre).

39/40
During varnish removal: This painting was covered with several coats of varnish that had darkened with age. The restorer has begun reducing the varnish layer at top left; the darkened varnish can still be seen in the middle, at the bottom, and on the right.
After partial removal: The work has recovered the tonal values and contrasts that successive layers of varnish had obscured; the flesh tones and the surrounding details have gained in legibility beneath the thin film of varnish that the restorer has deliberately left on the paint layer. Friedrich Sustris, *Venus and Cupid* (Louvre).

century (Poussin, Van Swanevelt, Velasquez, etc.).[74]

The correct treatment is to try to recondition the paint by means of a solvent.[75] If the bloom resists (i.e. if the pigment-medium interaction is irreversible) it is left visible as evidence of a technique and materials that were in use at a particular period.

premature craquelure affecting the paint layer only and not the ground (e.g. the lapis-lazuli blues of Fouquet's *Charles VII* in the Louvre). Its presence generally indicates that the artist broke one of the basic rules of painting technique. If different paint layers have interacted it suggests either that he failed to observe the rule "fat on lean" (based on the fact that a "lean" coat containing little oil adheres poorly to a "fat" coat containing a lot),[76] or that he used too many insulating coats of retouching varnish, or that he applied his final coat of varnish too soon, disturbing the normal drying process. Interaction between pigments and medium may indicate excessive use of drying inhibitors[77] or simply that too much medium was mixed with too little pigment. Or the artist may have made excessive use of other materials: bitumen (which nineteenth-century artists mixed with their paint and which is very difficult to dry out in depth beneath varnish),[78] wax, drying agents, etc.

Another irreversible development. There is no accepted treatment for paint-layer craquelure provided that it is fine enough not to affect one's reading of the work. Where excessive use of bitumen or drying agents has provoked a network of very broad cracks, revealing a light-colored ground and therefore standing out very vividly, the restorer will attempt to re-establish the unity of the work by toning the cracks down with glazes. In the other cases there is no call for intervention.

abrasion of the glazes forming the top film of the paint layer as a result of over-violent attentions having been paid to a not yet dry painting by thoughtless or inexperienced restorers.

Again irreversible (a part of the painting's "skin" has been removed), this type of deterioration is left untreated if it does not seriously affect the work's appearance. If it does, the restorer must glaze the "skinned" areas at long intervals or spot them out (ills. 43, 44).

loss of cohesion in the paint itself, due either to poor-quality materials, or to dessication (the paint was mixed too thinly, the ground was too absorbent, or the *impasto* was too heavy), or to the absence of a protective varnish layer (e.g. in paintings of the second half of the nineteenth century, particularly by Impressionists).[79]

Mat, light-colored paint the restorer will refix with glue, other types of paint with wax.

41
During varnish removal: This painting was covered with dirt and yellowed varnish (a sample has been left). First the dirt was removed; then the varnish layer was reduced little by little, revealing the delicate effects in the boy Jesus's yellow robe with its red lake shadows and gold leaf decoration. The deliberate contrasts in value between adjacent light and dark areas had been obscured by the unifying effect of the discoloured varnish layer; the whole picture had lost depth. Gerini, *Virgin and Child with Eight Saints*, detail of Jesus's robe (Petit Palais, Avignon).

a *lacuna or lacunae* due to accidental damage or, in the case of paint without much binding matter, to loss of cohesion with age.

The treatment indicated here is either to fill and retouch, in the case of relatively recent paintings where the ground has not yet acquired the characteristic craquelure that comes with age,

or, in the case of a damaged Primitive, to leave the ground and its network of craquelure exposed, such *lacunae* being consistent with the character of the work,

or alternatively to cover the exposed ground with a transparent glaze that will restore the unity of the work while still allowing the craquelure to show through.

retouches, dating from a previous restoration.

If the retouches are well integrated, i.e. if they are confined strictly to the damaged area and match the original for color, they do not call for treatment.

Retouches that extend beyond the actual damaged area and cover up original material must be removed in order to expose this and redone in such a way as to fill the damaged area and no more.

Retouches that have changed color with age and now stand out must be removed and redone.

A more difficult case are retouches that represent a significant modification of the work. If they are of historical or aesthetic value, and particularly if it can be established that the "original" is either missing or damaged beyond repair, such retouches are usually left.

The history of restoration offers many examples. If on the other hand the restorer feels that these retouches have no special aesthetic quality, and if the original beneath them can be recovered, even if in an incomplete state, then they are removed. Depending on what is exposed, the restorer will proceed either to retouch minimally, leaving the *lacunae* (the strict conservationist position, as opposed to that of restoration), or to reconstitute the missing portion or portions in a way that is visible from close to but not from a distance (this would be the case for a Primitive, for example), or, in the case of a painting dating from the sixteenth century or later, he may execute a piece of invisible retouching confined strictly to the area from which paint is missing.

The ground

Most types of deterioration affecting the ground are caused by a more or less drastic weakening of the medium or binding agent with age. This is an irreversible process and, as such, not subject to treatment. It takes the form of a gradual loss of cohesion and adhesion, resulting in:

"age" craquelure, a network of cracks running

42

During varnish removal: Varnishes were sometimes artificially tinted, as this one was with bitumen. This gave a picture an antique look much admired in the nineteenth century as well as serving to cover up damage. In this case the layer is being thinned down. Samples of the dark varnish still remain. Bourdon, *Deposition,* detail: the face of the Virgin (Louvre).

right through the picture layer, ground included. This is due above all to play in the support subjecting the ground to stresses, with wood and canvas both producing their own distinctive type of craquelure (ill. 48). It is the outcome of the normal process of aging affecting the picture's components, though it may be aggravated by sudden changes in relative humidity or shocks received in transit.

As a rule, no treatment is attempted.[80]

Craquelure may also be due to a thick, heavy ground having been applied to a canvas too thin to support it properly, as happened frequently with such Neo-classical painters as Ingres.

Relining will provide a more solid support here and bring the craquelure back into a flat plane.

lifting, which may be the result either of loss of adhesion between ground and support or of loss of cohesion within the ground itself. In a typical case of lifting in a canvas painting the paint layer will start to break up into scales.

Moderate damage due to lifting can be treated by local refixing. More advanced deterioration will call for refixing from front and back (with the adhesive passing through the original canvas, provided that this has a loose enough weave followed by relining. Lifting of the ground from a wooden panel is treated by repeated refixing (ill. 50).

blistering, another and more serious type of lifting caused by faulty conservation conditions, i.e. a humid environment, or by damp imprisoned inside the picture when, as often used to happen, oil paint was applied to the back of a new canvas too soon after a glue relining, preventing the glue from drying properly.

Localized deterioration of a not too serious nature can be treated by refixing from the front in the case of a panel painting and by refixing from front and back followed by relining in the case of a painting on canvas. If the damage is extensive and has reached an advanced stage it will be necessary to carry out a partial or complete transfer of the painting (in the case of canvas) or give it a wax-resin impregnation if the ground is neither mat nor light.

lacunae or missing portions of the entire picture layer – varnish, paint, and ground – due to poor conservation and failure to treat incipient lifting in time (ill. 49).

The "reintegration" of *lacunae* will depend on their extent and where they occur. It is achieved by filling the hole up to the level where it can be retouched. The purist approach, and the approach adopted when a work is so badly damaged that the restorer could not retouch without inventing, is to leave the *lacunae* as they are, with, in the case of Primitive panels, the wooden support showing through.

43
Damage from cleaning: Earlier cleaning operations have worn the paint layer over irregularities in the canvas, bringing out the weave even more markedly. No action is called for; retouching would only dull the work. Poussin, *The Hebrews in the Desert,* detail (Louvre).

We have briefly summarized the types of deterioration affecting the three elements of the picture layer, examined their respective causes, and defined the appropriate treatment. The causes can be gathered under five main headings: poor choice of materials, violation of the basic rules of painting technique, the normal process of aging, accidents of conservation, and faulty restoration. Before we go on to deal in more detail with the treatments recommended we ought to take a closer look at the first and second of these causes, since they often present the restorer with insoluble problems.

Up until the end of the eighteenth century painters were also craftsmen in the full sense of the word. They prepared their own canvases or panels, they ground their own colors, and they respected the essential rules of painting technique. The works they created are as a rule excellently preserved, having suffered, apart from the odd accident of conservation, only from the normal process of aging.

The pupils of David (i.e. Ingres, Gros, Girodet, etc.) ushered in a new era of imperfect craftsmanship and reduced technique that had disastrous consequences as far as the preservation of their works was concerned. When for example bitumen was used in depth rather than as a glaze and then covered with varnish it dried only with difficulty. What happened was that the surface formed a rigid skin while the paint underneath, drying more slowly, shrank into islands separated, when the skin burst, by broad cracks in the effect known as "crocodile skin". The *Portrait of Cherubini* (Louvre) is disfigured by a network of such cracks as a result of the serious errors of technique committed by its painter, Ingres. Delacroix, who never had much

time for the craftsmanship aspect of his profession, used too much bitumen in his *Dante's Bark* (Louvre; ills. 46, 47) with the result that the picture layer has cracked in a most unattractive way. Moreover bitumen tends to lose its lovely russet color with age and turn black instead – an unfortunate example of this being Prud'hon's *Christ on the Cross* (Louvre). A similar amount of damage was done during the Romantic period through the misuse of drying agents and fatty oils. All these examples of deterioration are irreversible and the restorer can do nothing about them.

With the second half of the nineteenth century and the Impressionists' attempts to achieve an absolutely mat effect, painters started to become careless in their choice of materials: their supports were often second-rate, their grounds were too absorbent, the commercial pigments they used were of uneven quality, they mixed their paint too thin, they covered their canvases irregularly, their heavy *impasto* work had a tendency to crumble, and they tried to do without a final protective coat of varnish. The resultant works are fragile to say the least.[79] The Impressionists were the initiators of a systematic break with the craft tradition in painting, and they found many followers.

Nowadays painters go as far as to flout every technical constraint. They mix traditional and modern materials without giving a thought to whether they

44
Damage to the paint layer: Here there has been some loss of pink and red paint due to abrasion of the paint layer, exposing the ground. Retouching will consist in discreetly spotting the worn places. Seventeenth-century French school, *The Sacrifice of Iphigenia,* detail: the draped figure of the high priest (Louvre).

will be compatible in the long run, and there is cause to fear that their works will deteriorate very rapidly, though of course many twentieth-century works are deliberately ephemeral. Only time will tell how synthetic materials, which on the face of it seem better suited to this type of creation, will age and how long they will last.

The restorer, obliged to keep up with these developments in technique, is faced with a difficult task[81] – a task that might conceivably be made easier in the unlikely event of painters being persuaded to accompany their works with a note giving details of the materials used!

45

◁ *Pentimenti:* The artist evidently had second thoughts about the position of this hand. The paint layer with which he covered up his original version of the fingers has gradually become transparent with the passage of time and that version now shows through. Such "ghosts" are known as *pentimenti* (from the Italian *pentirsi,* "to repent"). In this case the *pentimenti* do not mar the work aesthetically and will be left visible; the restorer will not even try to neutralize them with discreet retouching. Suvée, *Cornelia, Mother of the Gracchi* (Louvre).

46/47

Premature cracking:
Whole: The shadows in this painting are marked by a network of wide cracks or channels in the paint layer. Detail: These wide cracks are due to the addition of bitumen to the paint, which interfered with the drying process. The surface of the paint layer dried normally but the paint underneath remained slightly moist; contracting with age, it slid on the ground and dragged the already rigid surface with it, producing these characteristic cracks. Delacroix, *Dante and Virgil* (Louvre).

48
Spiral cracking: Cracking develops in a network at right angles to the forces present. If the forces impinging on one point were equal in all directions, the resultant crack would be circular. Since they are different in all directions the crack forms as an irregular spiral, its centre corresponding to a weak point of some kind (a knot in the canvas, a blow, etc.). The photograph also reveals some dangerous flaking; in fact two little flakes have already come away. The original canvas has evidently deteriorated to the point where it is no longer capable of supporting the paint layer, and the picture will have to be relined. Fragonard, *Inspiration,* detail (Louvre).

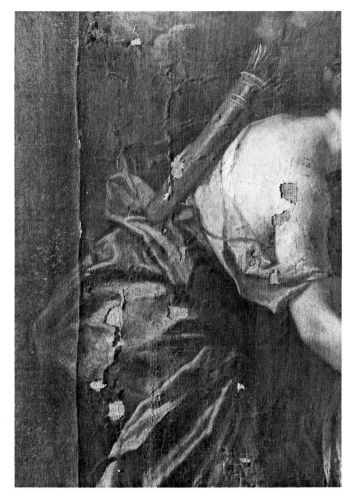

49
Blistering and loss of paint: This picture was accidentally exposed to damp, which caused the canvas to shrink slightly and impaired the ground. The paint layer blistered as a result; some of the blisters burst; and there has been a certain amount of paint loss. The painting will have to be transferred because the original canvas is now too close-textured to admit adhesive for reattaching from behind. Marot, *Diana and the Nymph,* detail (Louvre).

REPAIRS

We defined the broad principles of restoration in our introduction. Here we should just like to stress that, as far as repairs are concerned, the restorer's job is not to restore the work to its original state

but to restore it to the normal present state of its original materials by removing as much as possible of what men and time have added (provided that those additions are not of historical interest in their own right) and by confining his own additions to the minimum necessary to permit a proper reading of the work.

No restoration should be undertaken before the restorer has made a minute study of the work both as a material and as an aesthetic object in order to give himself something to go on. Following examination with the naked eye, under the microscope, and in the light of his laboratory records,[82] he will then form a diagnosis; but the only way of confirming or invalidating it is to carry out trials on small, insignificant areas of the painting. These

50
Flaking: Changes in relative humidity have made the wooden support shrink, which has caused flaking of the paint layer along the lines of the grain (see beneath the Virgin's left eye). The thin paint layer will have to be reattached with the aid of a wax-resin mixture. Sixteenth-century Italian school, *Virgin and Child*, detail (Louvre).

trials are extremely important; every painting is different, and no method of examination, however precise, can take the place of experiment.

Examination reports, trial reports, scientific documents, and records of previous restorations together make up the work's medical dossier, as it were. This will be added to by a photographic record of the restoration process.

67

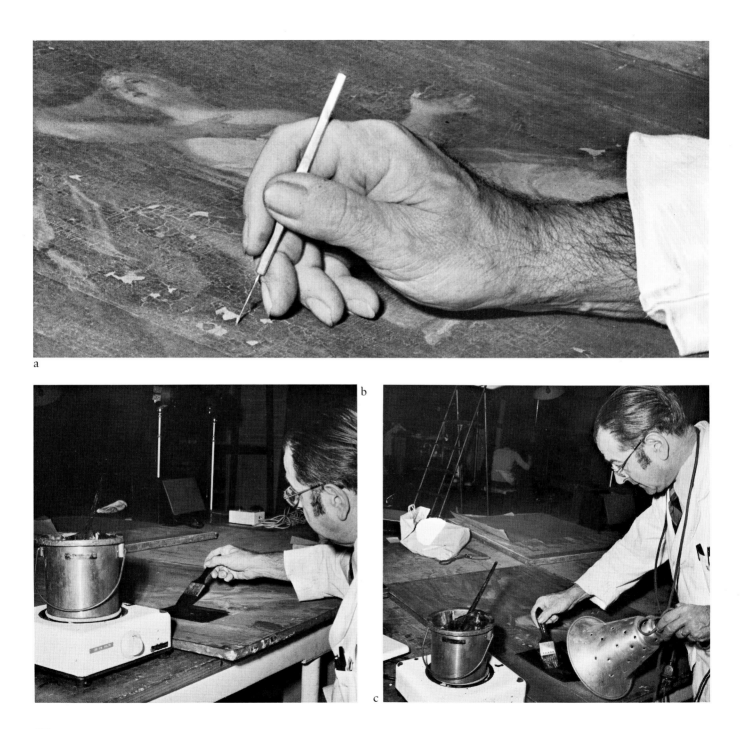

a

b

c

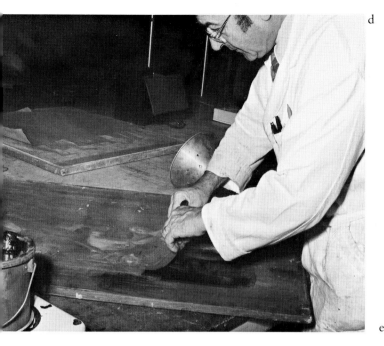

d

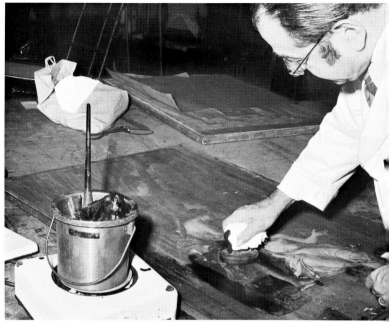

e

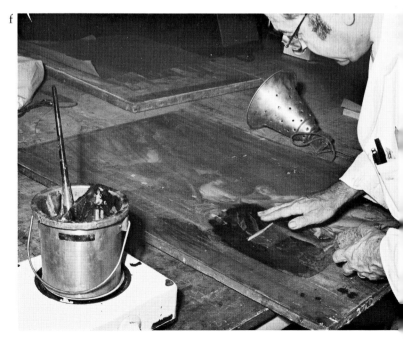

f

51–56
Refixing:

a) The restorer lances the blisters to admit the adhesive needed to reattach them.

b) He heats the glue size in a double boiler and applies it warm with the brush to the blistered area.

c) He warms the affected area gently with an infra-red heater. This will keep the adhesive fluid and improve its penetration.

d) He covers the whole area with tissue paper, which protects the painting during ironing but still allows him to see what he is doing.

e) Ironing: the blisters are flattened and the paint layer re-adhered to the ground.

f) The restorer dampens and removes the protective paper. The picture is now ready for varnish treatment and retouching.

All the methods of restoration cited are as safe and effective as the skill, experience, critical knowledge, and artistic sensitivity of the restorer make them. This is really the key point. The restorer alone must be allowed to touch the actual substance of the work of art. The art lover should never try to restore his own paintings. Even if he used the right products he might do untold damage, for what counts above all is the way in which those products are used.

Let us now look a little more closely at the types of treatment and repair that we have mentioned as being applicable to the picture layer of a painting.

Repairs to the varnish layer

Dusting is done with a soft cloth or special feather duster with flexible quills.

Wiping is done with a cloth duster or soft brush, with a little extra pressure and polish being required to get rid of the bluish look on the surface of the varnish.[83]

The *removal of grease and dirt* is achieved by wiping the surface of the varnish with a pad dipped in water and turpentine or, if the dirt resists this, with water containing a few drops of ammonia (the quantity varying according to the amount of dirt to be removed and also according to the age of the painting and the technique the painter used. The varnish layer must be dried immediately; no moisture must be allowed to remain on it. A scalpel or needle may be necessary to remove fly-specks or dirt lodged in the hollows of *impasto* work.

In the past restorers tended to use harsh cleaning agents – potassium lye, diluted nitric acid, soda,

urine – that not only damaged the varnished layer but even ate through to the paint.[84]

The purpose of *reconditioning* is to restore the transparency of varnish affected by bloom (ills. 32–34). It is done with solvents used either singly or in mixtures (alcohol is the most usual one) and calculated to act neither too slowly nor too fast. Using too slow a solvent or too much solvent may result in damage to the paint layer. The solvent is applied with a broad, square brush in single strokes or alternatively with a spray, the point being to avoid the danger of carrying varnish from one part of the surface to another. Here again, success depends upon the way in which the restorer uses the products at his disposal.[85]

From 1863 on the so-called Pettenkofer method (named after its German inventor and based on the use of alcohol vapor) enjoyed a period of international favor before being very quickly abandoned.[86]

The operations known as levelling, reducing, and devarnishing are designed to correct various undesirable conditions of the varnish layer.

Levelling consists in carrying varnish by means of a solvent from areas where there is too much of it to areas where it is too thin. It is also used to fill in small scratches and holes in the varnish layer.

The key operation known as *reducing* aims to remove superfluous coats of varnish while leaving the original varnish layer, if this is still present, or whatever the paint layer was originally protected with (ills. 37–42). Reducing – as opposed to complete devarnishing – is practiced for reasons both aesthetic and technical:

Aesthetically it is desirable not to expose the disparate way in which the different colors of the work

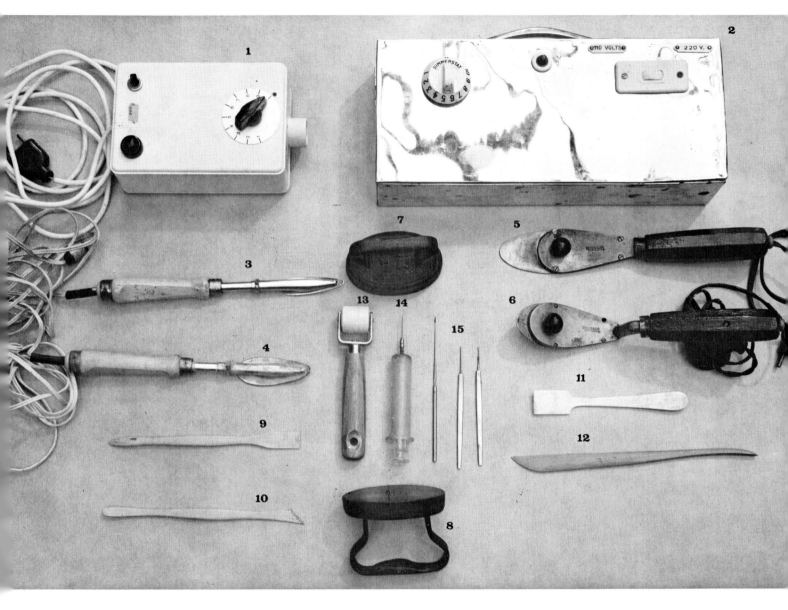

57

Materials for refixing:

For warming and pressing: rheostats (1, 2) – large electric spatulas (5, 6) – small electric spatulas (3, 4) – smoothing irons (7, 8).

For pressing and removing surplus adhesive: roller (13) – wooden spatulas (9, 10, 12) – ivory spatula (11).

For injecting and lancing: hypodermic syringe (14) – three lancets (15).

58

Damage to the paint layer due to the canvas having been folded: This painting has been relined and is now being filled. A tear is visible on the right and traces of a fold on the left — accidents to the original canvas that have fractured the paint layer and caused paint loss. Mignard, *Neptune Offering his Wealth to France* (Museée National du Château de Compiègne).

will have aged, i.e. the dark colors grown darker and the light colors remained as they were or grown lighter. Removing the whole depth of the varnish layer would only draw attention to this unfortunate trick of time.

Technically the reducing process is concerned first with respecting the delicate final glazes that painters sometimes applied themselves on top of an initial coat of varnish and that were generally based on a resin medium susceptible to the same solvent as the varnish. Glazing, an ancient technique already mentioned by the monk Theophilus, was used by the Italian Primitives, an example being the transparent yellow lakes of Marcovaldo's *Madonna de Coppo* (Chiesa dei Servi, Sienna).[87] We know that Titian often finished off his paintings with glazes. Velasquez, Delacroix, Courbet, and many other artists also went over their varnished canvases with colored glazes.

The second technical concern is to avoid bringing solvent into contact with the paint layer, since the paint would lose cohesion as a result.[88]

The object of the reducing process is to preserve the patina of the work of art, i.e. the evidence of the passage of time, while at the same time making the work more legible. It aims to fulfil both the historical requirement of conservation, which is that the work of art should be preserved as a witness to its period, and the aesthetic requirement that the work should be kept legible enough to be enjoyed as art.

The *techniques of reducing the varnish layer* are two in number:

The so-called *dry method* was formerly used on decomposing varnish that had begun to powder. This was reduced simply by rubbing or "rolling" it off with the fingertips. The method seems to have been in use from the eighteenth century onwards

59

Overpainting: Some old overpainting extending over the original paint has darkened with age. Restoration will consist in cleaning the surface, removing the overpaint, filling the damaged areas, and retouching to establish chromatic unity. Fifteenth-century French school, *Crucifixion and Legend of St. George* (Louvre).

but is no longer practiced today for two reasons: firstly it allows no visual control because during the operation white powder obscures the picture and it is very difficult to avoid taking off all the varnish and sometimes even damaging the glazes; secondly there is a risk of rubbing the ridges off *impasto* work.

The *wet method* uses solvent to soften the varnish and allow the restorer to remove as much as he feels necessary to lighten the painting underneath. It is in fact the same method as is used to carry varnish from one part of an uneven varnish layer to another or to fill in scratches and holes.

The *extent to which the varnish layer should be reduced* is decided on the basis of a series of trials made to different depths on a variety of colors; it will be governed by the kind of difficulties encountered and by the historical and aesthetic criteria mentioned above (ill. 35).

The usual *procedure* is to apply the solvent with a cotton bud if the picture is a small one or, in the case of a larger picture, with a graining brush or even with a cotton-wool wad, if the restorer prefers to judge with his fingers how the varnish is reacting. On *impasto* work the chemical reaction can be combined with the physical action of a short-haired

61
Removing overpaint: The royal escutcheon with its fleurs de lys was once slashed in an act of political vandalism. A crude piece of restoration subsequently killed two birds with one stone, as it were: a sheet of paper glued to the surface of the painting repaired the rent and at the same time covered up the fleurs de lys. The slashed canvas calls for relining. To restore the surface, it will first be necessary to remove paper and overpaint. Lafosse, *The Triumph of the King* (Musée de l'Armée, Paris).

60
After restoration, with a sample of old overpaint left: The restorer has left a discreet sample (centre) of the overpaint that once encumbered this late fifteenth-century work. The Virgin's cloak, which had suffered some damage, had been extensively overpainted, covering up the original trellised gold border. A recent restoration carried out at the Central Institute of Restoration in Rome removed this overpaint out of respect for the original and confined retouching to the areas of actual damage. Lieferinck, *Crucifixion* (Louvre).

brush or scalpel to remove the softened varnish and any accompanying dirt from the nooks and crannies. If the picture is badly crackled and beginning to lift its surface it must be refixed by means of relining before any attempt is made to reduce the varnish layer; solvent must on no account be allowed to penetrate open cracks and attack the ground, and it will in any case be impossible to make a good job of reducing on an uneven surface.

62
Deceptive retouching: The support has been consolidated and the shield retouched. This type of retouching, known as deceptive retouching, draws on existing elements to reconstitute form and colour.

63
Removing overpaint: Working with a scalpel under the microscope, a restorer removes unwanted overpaint from a picture.

The *solvent* used must effectively soften the varnish in order that it can be removed, but it must also be volatile and evaporate fast. The softening action of such essential oils as rosemary, cajeput, spike oil, and turpentine is well-known. Acetone and ethyl alcohol on the other hand are quick-acting solvents. A mixture often used is alcohol and turpentine; this combines the two properties, with the turpentine as it were neutralizing the effect of the alcohol.

Restorers treating an old varnish do so with a brush or wad soaked in an active solvent in one hand and a wad soaked in turpentine in the other hand with which to arrest the process when required. A modern varnish will react sufficiently to turpentine alone.

Between these two extremes the modern restorer can choose from a whole range of solvents that, used singly or in combination, offer a wide variety of possibilities.[89] Only experiment can show which is the right one to use in any particular case and how much of it is needed. But if the choice of the solvent is important, the way in which it is used is even more so. The decisive factor is the quality of the restorer's control throughout the operation.

Reducing a varnish layer is more difficult than

64

After filling: This wooden panel is made up of a number of boards that had moved under the influence of changes in relative humidity, lifting the paint layer and eventually provoking considerable paint loss. Following treatment of the support, the lacunae have been filled and are now ready for retouching. Seventeenth-century French school, *Les Singeries du corps de Garde*, "Monkey business in the guardroom" (Louvre).

removing it completely. Probably one cannot hope to achieve a perfectly uniform result. In the case of varnishes mixed with wax, glue, or oil it is a technical impossibility. But with normal, pure varnishes applied in successive coats it can in fact be done. The key factor is the restorer's skill in selecting the right product and using it in the right way. "Errors through prudence are open to correction; errors through presumption are irremediable."[90]

Occasionally, however, despite his aversion to taking so radical and irreversible a step, the restorer may be obliged to proceed to complete *devarnishing*, removing all the varnish from the surface of the work right down to the paint layer. The work to be restored may for example have been so extensively retouched in the past that the whole paint layer needs to be exposed in order to remove all non-original paint. The technique is similar to that used in reducing, but solvents and diluents are used in different quantities and combinations. Up until the beginning of the twentieth century there was only a limited range of comparatively unsophisticated products available. All restorers appear to have gone in for complete devarnishing, with the more prudent among them confining themselves to the highlights of a painting and leaving the darker

a

b

c

65–67
Filling:
a) A lacuna in the paint layer exposing the wooden support – a piece of oak with the grain running horizontally.
b) The lacuna has now been filled with putty (whiting and glue size) to bring it up to the level of the paint layer. The putty must be allowed to dry before being rubbed down.
c) The putty is now being rubbed down. Filling must be confined strictly to the actual area of paint loss and, in the case of a smooth-textured painting such as this one, be absolutely flat. After rubbing down (as on the right here) the area will be ready for retouching. Seventeenth-century French school, *Les Singeries du corps de garde*, detail.

areas of more fragile paint untreated – resulting of course in a loss of overall harmony and balance. Less discreet restorers not only took off the entire varnish layer but often "skinned" the paint layer as well, covering up the damage afterwards with overpaint. Obviously cleaning and varnish treatments,

being irreversible, are much more important with regard to the future of a work of art than retouching, which can always be done over again.

Reducing, devarnishing, and the whole momentous question of cleaning paintings have been the object of some deeply-felt polemics between the advocates of total removal and those of a more moderate, subtle approach. In the eighteenth century art lovers cultivated a taste for the patina of age, which they felt ennobled and deepened the harmony of the work of art. The allegory of Time as an old man completing a painting was very popular. In the early nineteenth century this taste for paintings darkened by heavy varnish layers continued, but towards the middle of the century one or two bold curators — e.g. in Dresden, London, Paris, and Munich — began to clean some of their paintings. We have already mentioned the paintings cleaned at London's National Gallery under Eastlake and at the Louvre under Villot and the violent opposition they aroused (see above, page 9).

The controversy continued into this century, reaching a climax in the 1947 exhibition of the paintings the National Gallery's team of restorers had cleaned over the previous ten years.[91] The exhibition divided artists, critics, and collectors into two camps. We can call them the "Anglo-Saxon" and "Mediterranean" schools, with the first favoring devarnishing for the sake of getting back to the

68
Lacuna in an impasto paint layer, calling for a textured filling: This impasto painting has flaked in places, exposing the canvas. Filling these lacunae will involve shaping the putty to match the brushwork of the area concerned before retouching it for colour. Nineteenth-century French school, *Landscape*, detail (Louvre).

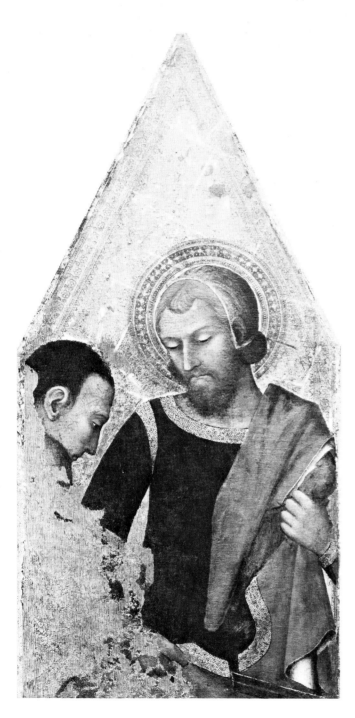

original state of the work and the second favoring a less radical approach based on a critical judgement to the effect that the acquisition of a patina is in some way an irreversible process. Fed by a veritable spate of literature, the debate raged for something like twenty years.[92]

I cannot think of a more fitting way of ending this section than with the words of Paul Philippot:

"The aesthetic problem raised by the cleaning of paintings does not take the abstract form of the alternatives total or partial devarnishing. On the contrary it consists, as we have seen, in a process of critical interpretation of the particular case in question with the aim of re-establishing as far as possible, given the current material condition of the work, not an illusory original state but the state most faithful to the aesthetic unity of the original picture. On this basis concrete solutions can be adopted according to the case in hand, covering the whole range of possible degrees of cleaning right up to the total removal of all varnish.

In practice, however, this last solution is only justi-

69

Minimal reintegration: Here the loss of original paint was so extensive and affected an area of such importance that the restorer decided against reconstituting the missing portion of the work, which would have involved a certain amount of invention. He has merely taken the "glare" out of the exposed ground, making it less obtrusive. Master of the Rebel Angels, *St. Martin* (Louvre).

70

Retouching by scumbling: The Virgin's blue-green robe has ▷ been freed of overpaint, revealing the original light ground with its craquelure. To restore chromatic unity without obliterating the cracks, these have been scumbled (overpainted with a thin tint). School of the Marches, *Virgin*, detail (Petit Palais, Avignon).

fied in exceptional cases since it will almost always interfere with the patina by elevating the material aspect above its formal transfiguration in the picture."[93]

Refixing

The purpose of refixing is to re-establish adhesion between the different elements of the picture layer or cohesion within a particular layer by means of an adhesive of one kind or another. If the paint layer is lifting badly in places it must be refixed before the varnish layer is reduced.

The adhesive used must be (a) fluid enough to penetrate and impregnate the layers to be refixed and (b) powerful enough when dry to stop any fresh lifting.

The different types of adhesive available are animal glues, wax, wax mixed with resin, and thermoplastic synthetic resins, the respective advantages and disadvantages of which are briefly listed below. Whichever type of adhesive is used, it must be able to penetrate to where it is needed, and in the absence of an open craquelure (ill. 51) or other mode of access the restorer is obliged – but only as a last resort – to prick the blisters of paint with the aid of a fine needle.[94]

71

A technique of the Primitives: juxtaposition: The Primitives obtained their modelling effects by the technique of juxtaposed lines (see the neck and cheek of the Virgin). This technique inspired the method of retouching known as *tratteggio* (Italian for "hatching"; see the crown of the veil). Paolo da Visso, *Virgin and Child*, detail (Petit Palais, Avignon).

Animal glues or gelatine include preparations made from bone, sinew, rabbit skin, parchment, cartilage, or fish. What happens is that the gelatin coagulates as soon as part of its water content has evaporated. Various softening or thinning agents are added, with each studio having its own particular recipe.[95] The warm glue is brushed onto the areas to be refixed (ill. 52), a sheet of light paper (tissue or Japanese vellum) is glued on top with a more watery mixture (ill. 53), and the lifting paint is pressed flat with the aid of an electric spatula heated to the right temperature or with a tiny smoothing iron (ill. 54). The ironing is done on top of the paper in circles beginning some way away from the blister and gradually moving closer. When the outer areas are softened first in this way, by the time the iron reaches the center the glue is sliding more easily. Finally the protective paper is removed with the aid of a damp sponge. This procedure varies slightly of course from studio to studio.[96]

The *advantages* of animal glues are:

Their variable fluidity ensures good penetration

They are identical in composition to most of the sizings and ground mediums used by the Primitives

They are neither shiny nor do they vary in color

They do not compromise future restorations; paint refixed with glue can subsequently be refixed again with any other kind of adhesive

Their *disadvantages* are:

The introduction of moisture may have the effect of undoing restorations carried out in watercolor, gouache, or recent egg tempera

Water may spread beyond the area being refixed and cause further lifting in future as well as local bloom in the varnish layer

83

Animal glues become brittle and lose their adhesive power with age, necessitating a repetition of the operation

Their use may foster the growth of micro-organisms (mildew) in a damp environment

Wax can be used as an adhesive either on its own or mixed with resin, the function of the latter being to stiffen it, raise its melting point, and stop it softening for example on exposure to sunlight. For centuries natural wax and resin were used; the emergence of synthetic forms has given modern restorers a whole new range of adhesives.[97] The mixture is applied warm as a liquid and takes effect as it cools. The procedure is the same as that used for refixing with glue except that at the end the paper is removed with solvent rather than with water.

Advantages:

Previous restorations using water or oil mediums are left unaffected, though there is a danger of wax retouches melting

Wax refixing gives lasting adhesion

The picture layer is not subjected to any stresses and strains

Wax is the only type of adhesive that does not lose its flexibility

Disadvantages:

Future restorers must also use wax

One is introducing an element that is different in kind from the ground medium

Colors will darken; with a porous ground *(gesso)* the wax will soak in and prevent diffusion of light, making the ground appear less white

To sum up, wax refixing or impregnation, though an irreversible process, is perfectly justified when the different elements of the picture layer are coming apart. It can be done either with a smoothing iron or on a hot table with the painting being subjected to a vacuum.[43] Local wax refixing is an effective running repair against paint losses.

Adhesives based on thermoplastic synthetic resins have proliferated enormously since their first appearance several decades ago.[98] They are applied in liquid form and become effective on polymerization once the solvent has disappeared. A physico-chemical change takes place, after which the product is no longer soluble in the solvent with which it was applied. In other words the use of synthetic-resin adhesives is irreversible.

Advantages:

They are easy to use, being applied cold

They dry fast

They are particularly suitable for use with (a) paint bound with a glue medium, where glue refixing would be tricky, (b) mat, powdery paint, where brushing would be difficult and the adhesive needs to be sprayed on, and (c) paint using an oil-wax mixture, which heat might damage

Disadvantages:

Synthetic resins differ in kind from the original materials and techniques of traditional paintings

72

Tratteggio retouching: The original paint of the Virgin's robe had completely disappeared. After removing a heavy coat of overpaint put on to mask the craquelure, the restorer opted for gentle reintegration by the *tratteggio* method. He has applied a screen of juxtaposed vertical lines in a variety of pure colours that the eye processes into one. This technique of retouching is visible from close to, but blends at a distance; the finer and closer together the lines, the greater the degree of reintegration. Taddeo di Bartolo, *Virgin and Child*, detail of the blue robe (Petit Palais, Avignon).

Our experience of them is relatively short and reactions or interactions may yet emerge

The solvents are highly toxic when used without special protection

The main thing to remember in connection with refixing is that the restorer must at all costs avoid being doctrinaire in his approach. Every painting is a case apart and needs to be carefully studied before a particular method is selected. It may even be possible to combine several methods. Like all restoring operations, refixing calls for a great deal of skill and experience if the restorer is to avoid inflicting fresh damage on the work he is trying to repair.

Removing overpaint

Overpaint dating from previous restorations needs to be removed if it has changed color, if it extends beyond the *lacuna* it was meant to hide and masks original paint, or if it covers up craquelure (ills. 59–61). The methods and products used in this process will depend upon the materials encountered. Basically there are two methods of removing overpaint:

The *chemical method* uses solvents to act either directly on the overpaint or, if this is very stubborn, indirectly by penetrating any open cracks and attacking the varnish layer beneath it. Direct contact between solvent and the overpaint of the retouched area can be prolonged by using a cotton-wool or blotting-paper pad soaked in solvent to slow down evaporation.

If the chemical method does not work the overpaint is removed *physically* by scraping it off with a

scalpel under the microscope (ill. 63). It cannot be stressed too often that every painting constitutes a case apart, and the restorer may for example be able to combine the two methods. Again it is his skill and experience that count most. Among other things he must know when to stop the process – i.e. as soon as he feels that further removal of overpaint may damage the original paint layer.

There are many *products* for removing overpaint and we can do no more than give a brief survey of them. Fresh tests must be made on every painting to determine how the overpaint will react and what it is applied to.

Retouches executed in *pure watercolor or gouache* without any varnish are removed with water.

Tempera retouches, which become very stubborn with age, are often removed with acetic acid (either diluted with water or mixed with turpentine).

Oil retouches to a tempera painting are removed

73

Modulated tratteggio retouching: A modulated piece of *trat-* ▷ *teggio* retouching (lower right) has enabled the restorer to reconstitute the elements of a lacuna while still leaving the extent of the paint loss visible. By modulating each vertical through several tones along its length he has succeeded in recapturing form and volume. Modulated *tratteggio* makes possible a higher degree of reintegration than simple flat *tratteggio*. Again the retouched area is visible close to and integrated from a distance. Lieferinck, *Crucifixion* (detail).

74/75

During restoration, after removal of overpaint:
a) The shadows, more delicate than the highlights, had become damaged and been overpainted, which had masked the craquelure. The overpaint has now been removed.
b) The restorer's pointillist retouching, very fine and approaching the deceptive, has respected the existing craquelure and the work has recovered its unity. School of Fontainbleau, *Gabrielle d'Estrées and one of her Sisters* (Louvre).

with basic solvents (e.g. dimethyl formamide diluted with a greater or lesser quantity of amyl acetate), which have replaced the harsher caustic sodas and potassium lyes that did so much damage in the past.

Oil retouches to an old oil painting are removed either by dissolving the varnish underneath them or by means of mixtures that, being somewhat unpredictable in their effects, call for a certain amount of experimentation beforehand.

Casein retouches tend to be very hard and are removed by scraping; any attempt at chemical removal would endanger the original paint layer.

Gold retouching was often done with powdered gold in a resin medium and can be removed with dimethyl formamide. Care must be taken if the original gold areas adjoining are pieces of gold leaf using a resin adhesive (e.g. clothing borders) rather than the bole armeniac that the Primitives used for their backgrounds and that is not likely to be damaged by this method. Many original gold backgrounds using bole armeniac have been ruined in the past by would-be cleaners swamping them with water; penetrating the craquelure, the water attacked the clay and glue of which bole armeniac is composed.

Filling

The object of filling is to bring the *lacuna* up to the level of the picture layer in order that it can be retouched (ill. 64). The two essential qualities of a filling are that it should be strictly limited to the actual *lacuna* and that it should be easily removable. Basically, fill consists of solid matter mixed with adhesive. It is usually white, though it can be colored if required to provide a better base for retouching.

As regards their *composition*, fills have varied very greatly over the centuries and from case to case and studio to studio, with white lead and a solid filler being mixed either with oil, wax, animal glue, or synthetic resin (vinyl or acrylic). The modern insistence on reversibility, i. e. that it should be possible to remove the filling at any time without endangering the original paint around it, has led to the abandonment of white lead as an ingredient, since in conjunction with oil it goes extremely hard with age. The types of fill most widely employed nowadays are:

Wax fill: This is flexible, non-brittle, and easy to remove when mixed with a solid filler. Wax on its own is translucent, allowing the network of craquelure to show through. The addition of a white or colored filler gives it a more reflective surface. The flexibility of wax fill offers great advantages for filling cracks or joints in wooden panels that are still subject to play. It has been used in all periods.

Glue fill mixed with chalk or kaolin is easily removable with water but is fairly brittle and will need to be renewed. It polishes well, giving an excellent reflective surface. Also it is usually homogeneous with the original ground, which means that it can do no harm to the latter as it ages. Glue fill has always been a favourite stand-by of restoration studios.

Synthetic fill has the advantages of being flexible, introducing no moisture, and not deteriorating with age, i.e. it does not crack or yellow. It can be removed by making it swell up with warm water

and digging it out with an implement. The fact that it is different in kind from the original ground leads to a risk of stresses that we are not at the moment in a position to estimate with any accuracy.

The *procedure* is to apply fill carefully to the damaged area (taking great care that it does not overlap), let it dry, and then rub it down or finish it off with a chamois leather (ills. 65–67). The completed filling should stop very slightly below the level of the surrounding paint layer so that when it is retouched it will be absolutely flush. It can be textured by pressing a piece of canvas onto it before it is quite dry, or it can be sculpted to reproduce the contours of *impasto* work (ill. 68), the object being to give the *lacuna* a comparable surface to the original paint left around it (ill. 58). The quality of a restorer's filling work will largely determine the success of his retouching.

Retouching

The object of retouching or reintegration, as it is sometimes called, is to color-match or reconstitute the missing portions of a work – without any invention on the restorer's part – in order to make it more legible. Retouching must satisfy the twin aesthetic and historical requirements defined by Cesare Brandi.

The *aesthetic requirement* is that accidents disturbing the continuity of a work of art should be disguised in such a way as to restore its real unity. The *historical requirement* is that all such accidents – even, under certain circumstances, extending to man-made additions and modifications – should be left visible as being interesting evidence of the work's passage through time. If strictly respected, the historical requirement would rule out any kind of restoration whatever.

The restorer's approach to retouching must be governed by these two requirements, the relative importance of which will vary according to (a) the extent and position of *lacunae*, (b) the period at which any former restoration was undertaken, (c) the presumed state of the paint underneath that previous restoration and the possibility of exposing it as assessed on the basis of sample trials, and (d) the period of the work itself and its aesthetic or documentary importance.[99] Again, every painting must be treated as an entirely separate problem and the restorer's decision based on a specific critical analysis.

Technically, retouching must satisfy three key requirements to which we have already had occasion to refer (see page 8):

Retouching must restore the *legibility* of the work while being confined strictly to the actual area of missing original paint. This "golden rule" of modern restoration emerged only gradually. In the Middle Ages holy pictures were commonly reworked to bring them into line with contemporary tastes. Even later, Primatice was not above redoing a foot by Raphael. Indeed right up until our own day restorers were in the habit of retouching more than the damaged area, sometimes covering up a great deal of original paint. A "restored" painting was often simply one that had been repainted. Respect for the original is a modern idea.

A second must for retouches is *stability*, which means that the materials used must be carefully

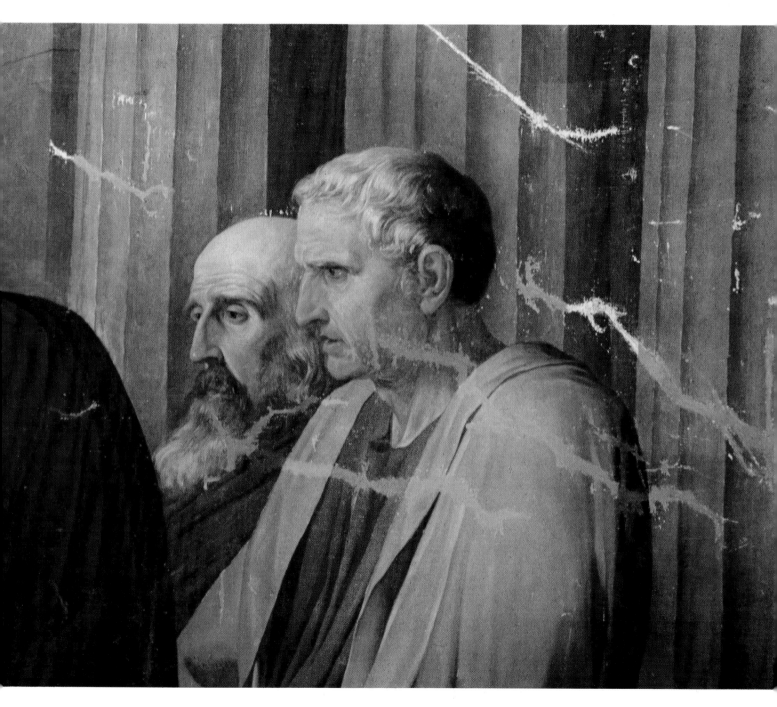

selected. We shall be going into this in more detail in a moment (see pages 100–103).

The third important requirement is *reversibility*, i.e. a piece of retouching must be easily removable without danger to the old paint around it. Consequently it must be executed in less resistant materials than the original. The modern restorer's approach is in this respect a more modest one: he does not believe that his retouching is "for ever".

There are various different *types of retouching* open to the restorer depending on the work he is treating and the damage it has suffered:

Invisible or deceptive retouching is designed to be undetectable with the naked eye. The colors are either mixed on the palette or they are applied in successive coats, i.e. an undercoat is laid over the fill (ill. 76) and the area brought up to match its surroundings by means of a series of scumbles or glazes (ill. 77). The undercoat will be lighter and "colder" than the final tone required (ill. 78). Each glaze will be insulated with a coat of retouching varnish to avoid any mixing. One method is to start with a gouache or egg tempera undercoat and cover it with a watercolor or varnish glaze or a very thin film of oil paint; derived from the technique of the painters of the Northern schools, this is the method used at the Institut Royal du Patrimoine Artistique in Brussels.[100] It is highly suitable for use on post-Renaissance works that have suffered relatively little at the hand of time or are incomprehensible with *lacunae* (ill. 79). Being based on superposition, it goes very well with works painted on the transparency principle. The work recovers its legibility, and the retouched areas can always be picked out by ultra-violet photography or other methods of laboratory examination (ills. 80,

81).[101] The museum-goer may fail to detect them, but not many specialists will.

Retouching designed to satisfy the historical requirement that *lacunae* should be left visible operates on the principle of being visible close to but appearing integrated when looked at from a distance. It achieves this by juxtaposing colors that become blended in the eye of the beholder, and it is capable of producing exceptionally pure, bright tones. There are two ways of going about it:

Tratteggio retouching uses a screen of parallel vertical lines in pure colors. The lines are placed one beside another and synthesized by the eye into the required shade. Different thicknesses of line give different degrees of subtlety of effect, and the technique allows of great freedom of execution depending on whether one is restoring a miniature or a fresco. As a retouching technique, *tratteggio* is derived from the original painting technique of the Italian Primitives, who obtained their modulations in this way, and it is of course particularly suitable for treating their works (ill. 71). It should consitute an abstract grille that, like a code, visibly indicates the extent of the retouched area.

76–78
Deceptive retouching: This painting on canvas had at one time been badly rolled on a cylinder too small for it and folds had formed. The paint layer had fractured, with consequent flaking and paint loss. Having relined the painting, the restorer proceeds to filling and retouching.
a) Filling: filling the lacunae (with white putty) is the essential preliminary to retouching.
b) Ground colour: the next step in deceptive retouching is to lay down a ground that is lighter and colder than the original.
c) The final scumble: the operation is completed by applying a final coat to match the restored area with the areas adjacent. Suvée, *Cornelia, Mother of the Gracchi* (Louvre).

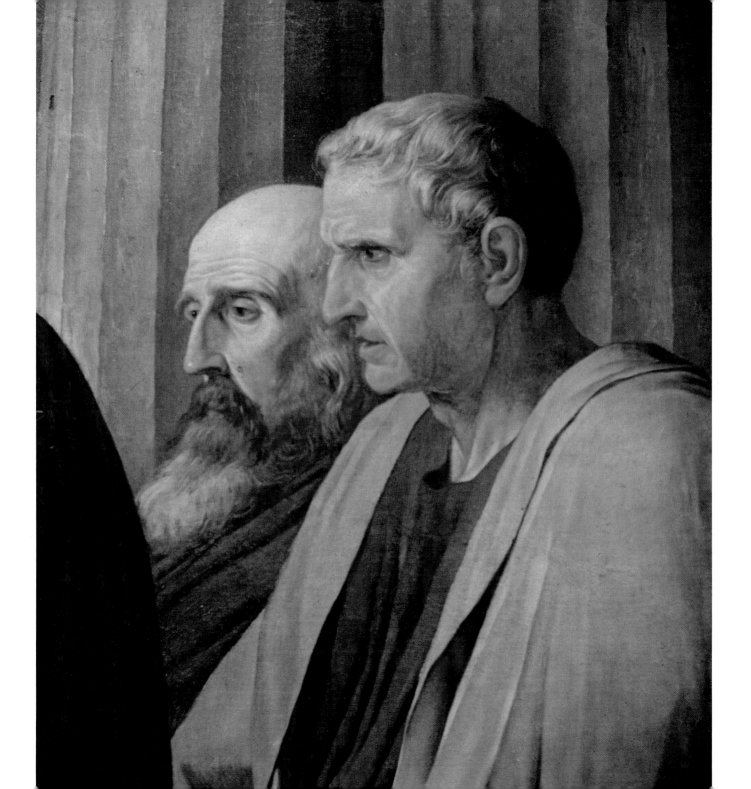

◁ *Deceptive retouching in progress:* This painting on canvas had suffered from folding and consequent fracture of the paint layer. It has been relined and the lacunae filled. The restorer continues by spotting the tiny damaged areas, taking care to keep strictly within each area. So far he has done most in the top central portion of the composition. This is an essentially decorative picture that calls for deceptive retouching. When restoration is complete the damage will be invisible to the naked eye. Coypel, *Decorative Figure* (Louvre).

There are various rules of *tratteggio* retouching. It must be applied to bright white fill, which will provide a reflective surface for the pure colors used, and not to original ground. (When the original ground of a Primitive painting is still there and has been exposed by abrasion of the paint layer, it is retouched with glazes applied along the craquelure.) Secondly the restorer must never use mixed colors, since these will give his retouch a leaden, dirty appearance. Thirdly, the lines of color must be kept strictly vertical (ill. 72); hatching to follow the line of the drawing or otherwise match the original more closely no longer complies with the principle of visible restoration.

The technique known as modulated *tratteggio* allows one to recreate volume and line by using two or more colors in a single line (ill. 73). This makes it more like the invisible, deceptive approach, although the retouched area is still detectable to the practiced eye. *Tratteggio* retouching, particularly the modulated variant, calls for enormous experience if it is to be done properly.

Pointilliste retouching – the second way of proceeding – consists in using dots of pure colors on the divisionist principle (and that of trichrome synthesis, which seeks to confine itself to the three primary colors). Again the colors as they appear are "mixed" by the eye.

Pointilliste retouching began with the optical laws of Chevreul, the experiments of the Impressionists, and Seurat's classification. It was already in use in restoring studios by the middle of the nineteenth century. It is suitable for use on various types of painting from various periods, and if well done it comes close to being invisible (ills. 74, 75).

Apart from invisible retouching and the type of retouching that aims to be visible close to but deceptive from a distance, a third approach is the *fragmentary method*, which on one and the same picture will deliberately leave some *lacunae* visible while reintegrating others. This may be appropriate for example in the case of a Primitive, where the wooden support is left visible in *lacunae* situated in less important parts of the composition where they do not disturb one's reading of the work; on the other hand *lacunae* in a vital part of the picture (e.g. a face) will call for intervention – precisely in order to restore the work's legibility. Fragmentary retouching is suitable for badly damaged Primitives and also for works of a documentary nature, where retouching should be confined to making the work coherent without attempting to be creative (ill. 69).

Removal of overpaint, deceptive retouching: ▷
a) This painting has a split in the wooden support that will be closed up by the cabinet maker. The work of restoration has begun with the removal of some old overpainting, revealing the extent of damage to the paint layer.
b) The lacunae have been filled. Retouching of the deceptive type, keeping strictly to the filled areas, has removed all visible trace of the lacunae. The face of the Virgin has recovered its unity. After Raphael, *The Virgin of Loreto* (Louvre).

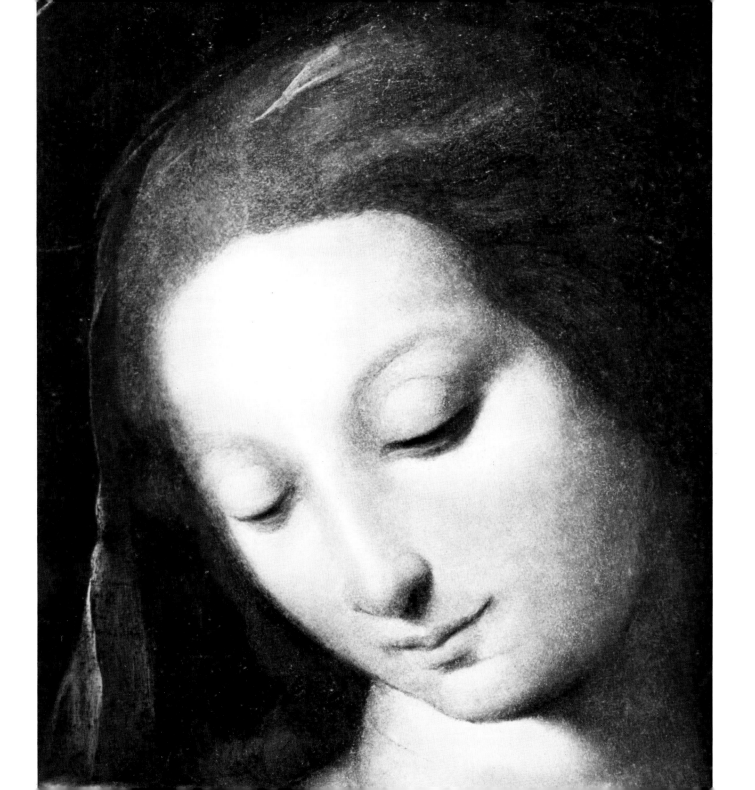

The restorer's decision, as always, will be the outcome of a thorough critical study.

There has been a gradual movement as regards the conception and execution of retouching towards greater and greater respect for the original. After a long period of improper restoration that, with a few isolated exceptions, lasted up until the beginning of this century, a purist reaction set in against even the most respectable examples of deceptive restoration. All deceptive restoration was considered tantamount to falsifying an original document. And of course there was the danger of a commercial type of restoration aimed primarily at the sales room i.e. the work must be presented in the best possible condition – as the prospective buyer saw it.

In the early part of the twentieth century the exclusively "back to the original" approach found concrete expression in the statement issued by the international conference of restorers held in Rome in 1930. Art curators, it was said, must educate the public by exhibiting paintings in their original state, however badly damaged. A suggested compromise was to divide museums into two sections – one for the art historian, who wishes to know the truth of the work, even if it is incomplete, and one for the art lover, who wishes to enjoy the work as an artistic whole; paintings would then be divided between the sections according to their state of preservation. Other positions adopted were even more extreme, and the solutions put forward were hardly practical.[102]

Between 1940 und 1950 visible retouching with *lacunae* being reintegrated in a neutral or lighter shade was adopted primarily for the restoration of mural paintings. The semi-visible *tratteggio* retouching perfected by the Istituto Centrale del Restauro in Rome is excellent for Primitives, meeting both aesthetic and historical requirements.[103] It is complemented by the *pointilliste* method for paintings from other periods. But completely deceptive restoration – nowadays confined strictly to the actual *lacunae*, detectable in the laboratory if not by the naked eye, ane executed in reversible materials – remains the most satisfactory solution in a great many cases.

The materials used in retouching

Paints

The two qualities required of the *paints* used for retouching purposes (both pigments and medium) are *stability* and *reversibility*.

The first thing to remember is that retouching materials can never be identical with the materials used by the original painter. Even if it is possible to identify these by laboratory examination or by means of documentation, certain pigments are no longer available and above all the original material has reached a stage of maturity that the fresh material has not begun to acquire. So absolute stability is out of the question.

As far as *mediums* are concerned, the rule of stability requires either that only a small proportion of medium is used (the case with gouache and watercolor) or that the restorer chooses a medium that suffers little or no deterioration in aging (i.e.

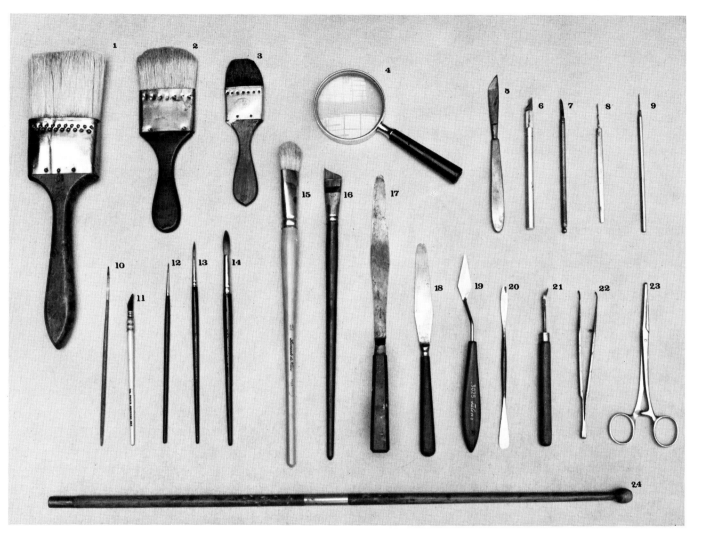

82
The restorer's tool kit
Illustrated is the selection of tools most commonly used:

For varnishing: bristle brushes (1, 2) – calf's ear brush (3).

For varnish removal: calf's ear brush (3) – flat brushes (15, 16).

For scraping off impurities: assorted scrapers (5, 6, 7).

For reattaching: lancets for lancing blisters (8, 9).

For filling: spatulas (20, 21) – palette knives (17, 18, 19).

For retouching: sable brushes for watercolour work (10, 11, 12, 13, 14, the latter two quill-mounted).
Tweezers for holding cottonwool swabs (22, 23) – maulstick (24) – magnifying glass (4).

101

one of the modern varnishes). Oil is out because of its tendency to yellow with age.

Pigment stability requires that these should as far as possible be used pure, without mixing. If they have to be mixed it is best to keep their number as small as possible in order to reduce the chances of interaction or other risky developments.

To qualify as *reversible* a piece of retouching must be capable of being removed at any time. So the medium must not become insoluble with age but must always remain more fragile than the original paint.

Paints employed in retouching are classified according to the medium they use:

Paints using a water-based medium (water-soluble gum arabic) are watercolor itself, using a lot of medium mainly for thin, translucent glazes or scumbles, and gouache, which with its higher proportion of pigments has greater covering power. Fully reversible and more fragile than original paint, both materials are widely used for restoration purposes.[104]

Tempera paints use egg as their medium – either the white or the yolk or a mixture of both. For a while they enjoyed great popularity, although it is difficult to hit exactly the right shade with tempera. The addition of fatty elements caused them to deteriorate and they were largely abandoned on the grounds that they darkened with age. Nevertheless tempera paints prepared by restorers themselves according to their needs are still in use in certain studios.

Varnish paints with their high degree of transparency were much used for retouching at one stage, although drying times were long. Nowadays natural resins have been replaced by vinyl and acrylic resins, synthetic products that are easy to use because one of the solvents employed is water. Additional advantages are that they dry quickly and do not darken with age. Their big disadvantage is that they are not soluble in the solvent that was used to apply them. Paint using a vinyl or acrylic medium may be more solid than the original. It would be desirable if restorers confined themselves to those of proven stability, though this is something only time can ultimately tell.

From time to time and from studio to studio other materials have been used for retouching: casein, wax[105] mixed with natural or synthetic resin, etc.

The trend as regards selecting materials for retouching has been towards greater and greater stability. Oil paint – the easiest to handle – was in use for centuries but was found to darken with age. As early as 1795 the expert restorer Jean-Baptiste Le Brun was no longer recommending it,[106] and its use has since been abandoned in most museum studios. Where it is still used it is first de-oiled on blotting paper and then mixed with varnish. The use of varnish paint goes right back to the late eighteenth century. Edwards introduced it in his Venice studio. It has always had its fans, though nowadays many of them have replaced natural resin with a synthetic product. Widely used nowadays are tempera and to an even greater extent gouache and distemper, materials complying with the key notion of reversibility that, together with that of stability, preoccupies everyone currently concerned with restoration.

We still lack the perfect solution. What is needed is for the results of the experiments and aging trials being made in various parts of the world to be collected together in the form of a permanent techni-

83
The studio: General view showing four restorers engaged in retouching.

cal record, classified according to materials and laying down the composition and properties of restoring paints. It should be kept continually up to date and manufacturers made to agree to abide by it.

Restoring glazes

Restoring glazes are translucent coats of paint applied thinly or locally in order to prevent a wtrn or strikingly altered passage of a painting from catching the eye unduly (ill. 44) or to mask without totally concealing an irritating *pentimento*. Ap-

plied between craquelure, a glaze will bring up or freshen a worn shade while preserving the surface appearance of the picture layer.

Varnish

Varnish is an essential element at various stages of the retouching process.[107] The point of so-called insulating or restoring varnish is to separate the coats of paint either from the fill they are covering, or from one another, or from the final coat of varnish in order to avoid undesirable interactions and also bring them up to the precise shade required. Such varnishes must not change color, i.e. not affect the way the retouched area ages; they must be fluid, in order to permeate the layer to be insulat-

ed; and they must be reversible, making it possible to remove the overpaint without any trouble. Alcohol varnishes are traditionally used for insulating and retouching, though diluted turpentine varnishes may also be employed. And nowadays there are the different synthetic products, which are applied in spray form. The object of the final coat of varnish, which should remain transparent without being excessively shiny, is to stabilize the overpaint, protect it from scratching, soiling, and atmospheric pollution, and to give the colors used their full brightness.

One very widely used type of varnish is based on tears of pure mastic resin dissolved in turpentine. It retains its transparency well and is easily removable, but it is often too shiny when just applied and falls off in shininess after a couple of months.

Synthetic resins (vinyl or acrylic), in use in the U.S.A. since about 1930, have spread throughout the world. They have the advantages of not yellowing and not being too shiny, but also the disadvantages of being removable only in their entirety, i.e. they are not reducible, and of having in the early stages of their use had the aesthetically undesirable effect of imparting a cold look to the works they were used on.[108] However, much progress has been made here.[109]

The problem of the ideal final varnish layer has yet to be solved. The classical method of final varnishing is to apply the varnish with a so-called fish-tail brush, crossing one's brush-strokes to give a homogeneous finish. Ways of cutting down excess shine are to (a) mat the varnish by stroking it lightly with the brush towards the end of the drying process, (b) lay a thin coat of wax on top of the dried varnish, (c) spray or roll on an extra coat of the same varnish to break the smoothness of the surface (and thus incidentally provide an extra layer of protection as well as additional security should the varnish layer need to be treated in future, or (d) spray the varnish on direct, which calls for a perfectly sure hand. Some studios use actual mat varnishes, but these are unsatisfactory; they involve introducing a heterogeneous element to the solvent-resin mixture – either tiny balls of glass or silica, which may cause abrasion if the varnish layer needs to be reduced at some time in the future, or more commonly wax, the presence of which makes reduction impossible and will necessitate complete devarnishing.

CONCLUSION

Restoration nowadays calls for harmonious collaboration between three types of expert: the art historian, the scientist, and the craftsman. The art historian studies the work of art as an aesthetic and artistic phenomenon; the scientist analyses the materials of which it is composed; the craftsman actually lays hands on the work in order to restore it. The three of them differ in the discipline they profess, in the training they have undergone, and in the language they speak, but if they all share an awareness of the problems involved in the conservation and restoration of works of art they will be able to communicate and co-operate in the interests and to the benefit of those works. In order to achieve this state of affairs in the years to come, each member of the trio must continue to be trained in terms of the imperatives of his particular field.[110] It is for the art historian to define the dogmatic framework and for the scientist to foster development of the appropriate methods, but both parties must first take their cue from the restorer.

For this much is true – and it makes a fitting conclusion to these remarks: the restorer alone has the peculiar and quite formidable privilege of actually putting his hand to the work of art.

TABLES

These tables constitute a highly simplified summary and can make no allowance for the nuances of treatment required in individual cases. And in restoration *every* case is an individual one. S.B.

Wooden support

CAUSES	DETERIORATION	TREATMENT
Choice of wood (slab-cut) Gradual, asymmetrical drying-out of a panel painted on both sides	Camber (curvature or warping)	None (no straightening)
Restrctie cross-grain elements	Beginning of a split (short)	Cleats on the back (after removal of the offending cross-grain elements)
	Long split with the edges out of level	Wedge-shaped incisions with inlays (after removal of the offending crossgrain elements)
	Joints coming apart	Wedge-shaped incisions with inlays (after removal of the offending cross-grain elements)
Weakening of the original glue with age	Joints having come apart	Reassemble with mortise and tenon jointing (after removal of the offending cross-grain elements)
Biological attack	Moderate worm damage (few galleries)	Disinfection and resin impregnation
Choice of wood (softwood, sapwood)	Extensive worm damage (many galleries, panel crumbling)	Thin down panel and glue to an "inert" support (core board); transfer no longer practiced

Following treatment of the panel: Maintenance repairs

SIZE OF PANELS	THICKNESS	SOLUTION ADOPTED
small	thick	none
small	thin	frame
large	thick	sliding crosspieces
large	thin	frame and sliding crosspieces

Canvas support

CAUSES	DETERIORATION	TREATMENT
Blow or shock	Tearing	
	Small tear with no distortion	Patching or repair of thread
	Small tear with distortion or Large ⌞ or ⌐-shaped tear	Relining (with gauzes in the glue method)
Climatic variation	Distortion	
	Moderate distortion	Play in the canvas is taken up with stretcher keys
	Serious distortion (puckering or when stiff)	Relining
	Seams standing up excessively	Relining
Nailing	Damage to edges	
Damp deposits (all around)	Moderate damage	Tension strips all the way round
Rubbing	Extensive damage	Relining
Folding or rolling (without a roll or on a roll of too small a diameter)	Fracturing of the picture layer	Relining
Weakening of the canvas, size, and ground	At a moderate stage: pronounced age craquelure network and traces of the stretcher outline	Relining
	At an advanced stage: picture layer flaking and blistering	Refixing from front and back followed by relining
Weakening of the ground	At a moderate stage: paint beginning to lift (flakes and blisters)	Refixing from front and back followed by relining
	Powdering (widespread lifting in flakes and blisters)	Semi-transfer, transfer, or impregnation
Powdering of the paint layer or several paint layers	Separation in the picture layer (between ground and paint layer or between paint layers)	If the canvas support is still sound: refixing. If the canvas support is no longer sound: refixing followed by relining
Lumps of glue from a faulty former relining	Hardened blisters	Fresh relining

Picture layer

CAUSES	DETERIORATION	TREATMENT
VARNISH		
Dust	Whitish look	Dry dusting
Damp and pollution	Bluish look	Wiping with a soft duster
Dirt deposits	Dirty look	Wiping with a wet pad
Damp	Bloom	Reconditioning
The relining process (cardboard)	Limited varnish loss	Levelling
	Extensive varnish loss	Devarnishing
Irregular thickness	Streaking	Levelling
Ultra-violet rays (natural aging)	Slight yellowing to pronounced darkening	No treatment Reducing
Common additives:		
Bitumen	Premature craquelure	Try reducing
Colored glazes	Excessive, irregular darkening	Complete devarnishing if necessary
PAINT LAYER		
Inherent	Powdering	Refixing
	Separation	Refixing or impregnation
Inherent, or changes in relative humidity, or blows and shocks	Lifting of paint layer from ground	Refixing or impregnation
Former repairs	"Skinning" of patina, glazes, or top paint film	None, or local glazing
Inherent	Increased transparency revealing:	
	the support	None
	pentimenti	None, or local glazing
Inherent (poor drying)	Premature craquelure	Usually none, or glazing
Former repairs	Retouches that:	
	have deteriorated	Removal
	overlap	Removal
	are of historical value	Keep if aesthetically acceptable
	are of aesthetic value	Keep if too much of the original underneath is missing
Changes in relative humidity or blows and shocks	*Lacunae*	Filling and retouching; with Primitives no treatment or at most glazing
GROUND		
Inherent, or changes in relative humidity	Lifting, separation between ground and support, and powdering (when not serious)	Refixing followed by relining
	Widespread lifting, blistering, or serious powdering	Semi-transfer, transfer, or impregnation
Changes in relative humidity or blows and shocks	*Lacunae*	Filling and retouching (no treatment in the case of certain Primitives)

FIGURES

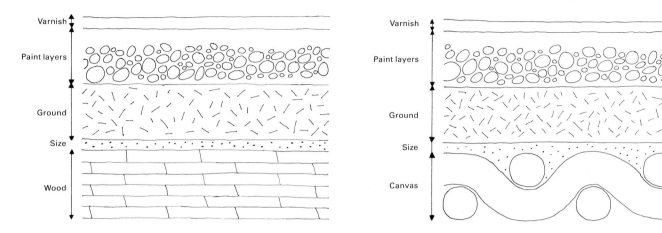

1. Structure of a painting on wood

1a. Structure of a painting on canvas

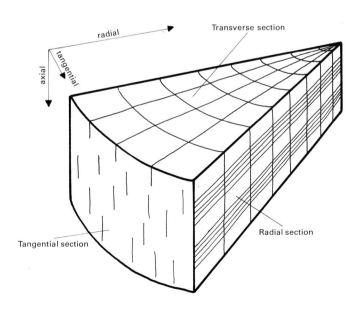

2. Ligneous plan

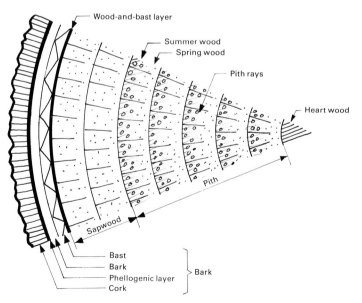

3. Transverse section showing age rings

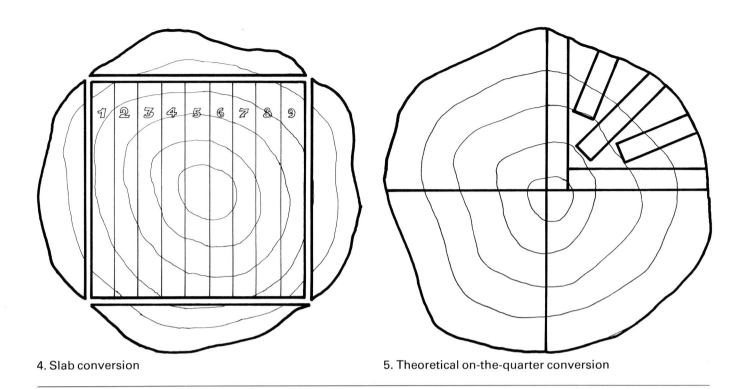

4. Slab conversion

5. Theoretical on-the-quarter conversion

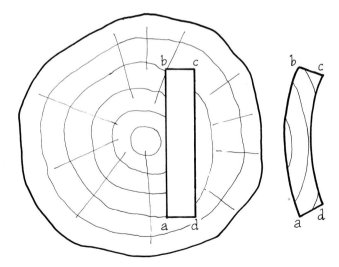

8. Distortion affecting a slab-cut board

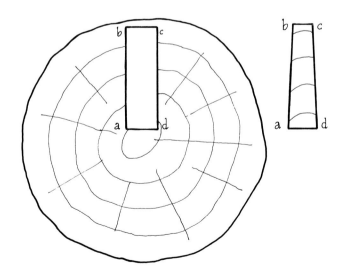

9. Distortion affecting a board cut on the quarter

110

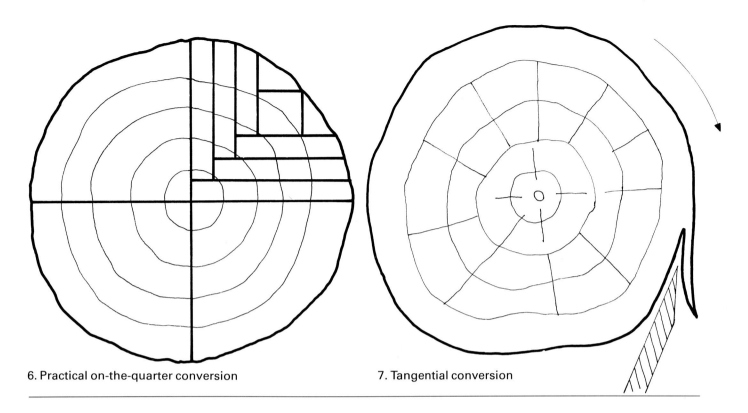

6. Practical on-the-quarter conversion

7. Tangential conversion

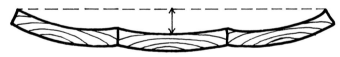

10. Three slab-cut boards, non-reversed, held at the ends

12. Three slab-cut boards, reversed and free at the ends

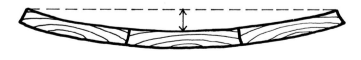

11. Three slab-cut boards, non-reversed, free at the ends

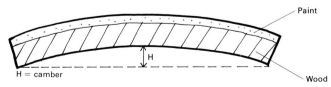

H = camber

13. A painted panel that has acquired a convex curvature

111

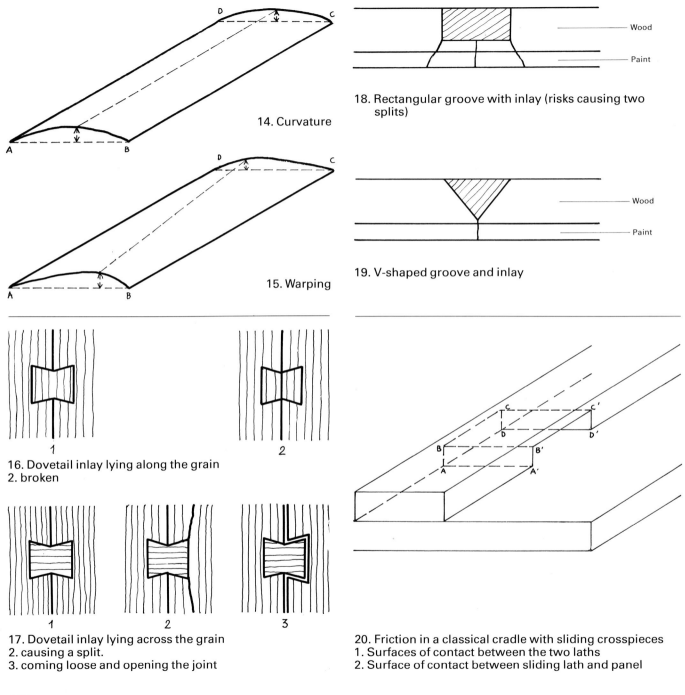

14. Curvature

15. Warping

16. Dovetail inlay lying along the grain
2. broken

17. Dovetail inlay lying across the grain
2. causing a split.
3. coming loose and opening the joint

18. Rectangular groove with inlay (risks causing two splits)

Wood

Paint

19. V-shaped groove and inlay

Wood

Paint

20. Friction in a classical cradle with sliding crosspieces
1. Surfaces of contact between the two laths
2. Surface of contact between sliding lath and panel

112

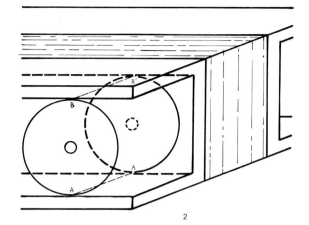

2. Friction surfaces reduced to two lines generating a cylinder

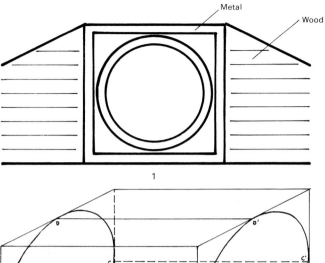

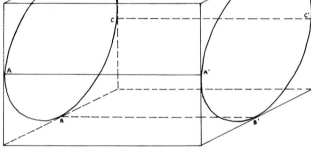

21. Friction in cylindrical sliding crosspieces
1. Cleat
2. Friction surfaces reduced to 4 lines generating a cylinder

22. Friction: Crosspieces moving on teflon rollers
1. Cleat

23. Plain-weave canvas: A woof thread (horizontal) passes alternately over and under a warp thread

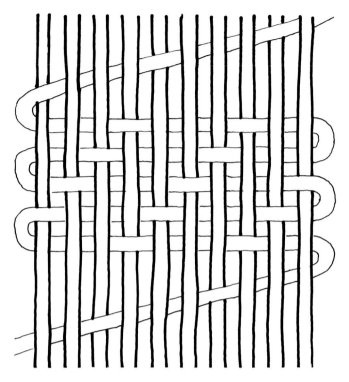

23a. Chevron or herringbone-weave canvas: A woof thread (horizontal) passes alternately over one warp thread and under three warp threads

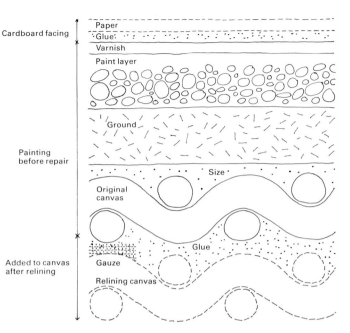

24. Relining

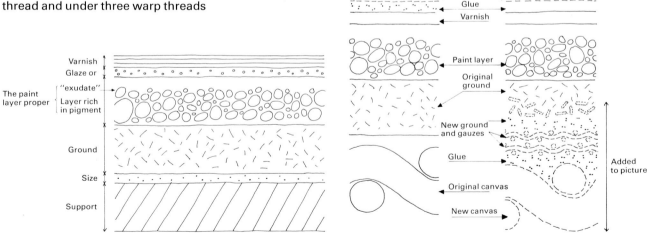

25. Structure of the paint layer

26. Transfer: canvas to canvas

114

I am indebted to Mlle S. Bergeon for the notes signed S.B. The references relate to the bibliography on pp. 124–128.

1 1967 BAZIN, p. 278

2 1967 MARIJNISSEN, p. 371.

3 1963 BRANDI; this bipolarity (aesthetic and historical demands that one re-establish the 'potential unity' of the work of art while committing neither historical forgery nor aesthetic offense.

4 1972 BALDINI, pp. 19–20.

5 1973 CONTI; 1963 FILATOV; in Russia damaged icons were repainted as a matter of course.

6 1967 MARIJNISSEN, p. 31; *rifiorire* involved covering an old painting with fresh paint.

7 1973 CONTI, p. 98.

8 1973 CONTI, p. 123.

9 1957 EMILE-MALE.

10 The members of the commission were the painters Taunay and Vincent and the chemists Guyton and Bertholet.

11 E.g.: 1927–1940: *Mouseion*. Revue internationale de muséographie. Office international des Musées. Paris.
1932–1942: *Technical Studies in the Field of Fine Arts*. Fogg Art Museum. Harvard University, Cambridge, Mass.
1943–1952: *Abstracts of Technical Studies in Art and Archaeology*. Freer Gallery, Smithsonian Institution. Washington, D.C.
since 1948: *Museum*. Unesco. Paris.
since 1950: *Musées et Monuments*. Unesco. Paris.
1950–1967: *Bolletino dell'Istituto Centrale del Restauro*. Istituto poligrafico dello Stato. Rome.
since 1952: *Studies in Conservation*. International Institute for the Conservation of Museum Objects. London.
since 1955: *Maltechnik*. Munich.
1955–1966: *IIC Abstracts*. International Institute for the Conservation of Museum Objects. London. Continued.
since 1966: *Art and Archaeology Technical Abstracts*.
since 1958: *Bulletin de l'Institut Royal du Patrimoine Artistique*. Brussels.
since 1959: Various publications of the International Study Center for the Conservation and Restoration of Works of Art. Rome.

12 1969 ICOM Paris, pp. 35–40. I quote P. Philippot, director of the International Study Center for the Conservation and Restoration of Works of Art: "One can move organically from a basically craft training to an intellectual type of training, but the reverse process is, with very few exceptions, inconceivable. The danger of seeing emerge a younger generation of restorers who know everything except how to use their hands is unfortunately not just a theoretical one."

13 1961 MARETTE, pp. 31–75.

Wood technology

14 The following brief survey will make it easier to understand the problems involved in the conservation of wooden panels:

The nature of wood

A tree is a living creature that is born, grows, ages, and dies. It consists of a collection of cell types with well-defined functions that together make up its *ligneous substance:* (a) fibres, which provide supporting tissue; (b) vessels to conduct the sap; (c) pith rays or reserve tissue.

The organization and nature of these elements of a wood constitute what is known as its *ligneous plan.* Being constant, this makes it possible to identify the wood. The ligneous plan of a wood depends on its color, on the contrast between spring and summer wood, and on its grain, texture, and star shake. The ligneous plan is characterized by three cutting directions: transverse section, radial section, and tangential section. If the fibres lie at right angles to the plane of the cut the wood is said to be cut against the grain; if they lie parallel it is said to be cut with the grain (fig. 2).

Looking at the cross section of a log of wood we distinguish: (a) the heart or duramen, where the fibres lie close together; (b) sapwood, where they are less densely packed; and (c) bark. A notable feature of such a cross section are the concentric age rings caused by the alternation of spring wood and summer wood and making it possible to deduce the age of a tree (fig. 3). During the spring, when sap is abundant, the fibres are swollen and spaced well apart, the wood light and soft; in summer, when there is less sap, the fibres are close together and the wood colored and hard.

Conversion of wood

There are several ways in which a log can be "converted" or sawn into planks:

1. Slab-cutting: The rings are either parallel or at an angle to the faces of the plank, the angle being greatest in planks 1 and 9, a little less in planks 2 and 8, and non-existent in planks 5 and 6 (fig. 4).

2. On the quarter: In so-called "theoretical" on-the-quarter conversion the rings are at right angles to the faces (fig. 5). The method is of course extremely wasteful. In "practical" on-the-quarter conversion the rings are at right angles to the faces of two of the planks and at a very slight angle in the rest (fig. 6). Less wood is wasted this way.

3. Tangential conversion: This consists in peeling off thin sheets of wood as used in the manufacture of plywood (fig. 7). Plywood was already known to painters in the mid-nineteenth century. S.B.
See also 1955 VILLIERES, pp. 140–146, 166–173; 1961 MARETTE, pp. 25–30; 1972 RIOLLOT, pp. 29–83, 74–78, 148–160.

15 *Free water and impregnation water.* The live tree contains water in two forms: what is known as *impregnation water* inside the cell walls, where it is closely associated with the cellulose, and *free water* circulating in the cell cavities. Once the tree has been cut it rapidly loses its free water; only the impregnation water is left, and that has a saturation point (between 25 and 30% water content). The dimensions of the wood have as yet undergone no change. As is ages it dries out further, gradually losing its impregnation water too. Its dimensions begin to vary in all directions (the phenomenon known as *anisotropy)* as the wood maintains a certain equilibrium with the ambient climate. Any sudden change in climatic conditions will bring about a corresponding change in the water content of the wood – due not to capillary action but to the fact that cellulose attracts water *(hygroscopicity).* The drying-out of a piece of wood, an inevitable process, does not take place regularly but is interrupted by periods of swelling and shrinking as determined by rises and falls in the water-vapour content of the surrounding air. S.B.

16 1952 BUCK, pp. 39–44.

17 In this section the treatments are simply listed without going into detail and without going into their historical background. The reader will find more information in the following section, entitled *Repairs.*

18 A possible solution here is to paint the verso in the

same way, insulating it too with a moisture barrier. See 1961 BUCK, pp. 9–20; 1963 BUCK, pp. 156–162; 1963 WOLTERS, pp. 163–164; 1963 THOMSON, pp. 169–170; 1972 BUCK, pp. 1–11.

19 This subject, so important as far as the conservation of Primitives is concerned, could be treated at very much greater length than is possible within the scope of the present work. See also 1959 Brandi; the major treatment performed on the support of Duccio's *Maestà* at the Istituto Centrale del Restauro in Rome combined several of the repairs referred to in this section. See also 1968 MONCRIEFF for an extensive general bibliography. 1974 URBANI, pp. 21–35 and 199–258, gives a recent survey of Italian researches and their application.

20 *Disinfection.* Gamma rays (high-energy rays produced by such radioactive substances as caesium 137 or cobalt 60) can in strong doses kill wood-eating insects. In treating wooden panels a comparatively feeble dose (25 kilorads) can be used to sterilize the insects. No radioactivity is developed in the wood itself. If, however, the wood is covered with paint using a *medium* that is liable to reticulate under high-energy treatment (e.g. a vinyl or acrylic medium), disinsecticization by radiation is not without risk. These treatments are under study at the French Atomic Energy Commission's Center for Nuclear Studies at Grenoble. An International Conference on the Application of Nuclear Methods in the Field of Art was held in Venice on 28–29 May 1973, and an Association Pronucleart was founded in the same year. *S.B.*

21 *Consolidation.* Gamma rays can also be used in the process of consolidation by impregnation. A badly wormeaten panel is impregnated with a polymerizable resin under a vacuum; the whole is then subjected to gamma radiation in order to harden it. This treatment, admissible for unpainted panels and gilded panels, cannot yet be used on pictures painted on wooden supports, there being a risk of the original mediums or glues dissolving in the solvent used to apply the impregnating resin. Again

trials are being made at the Grenoble Center for Nuclear Studies, and Group 18 at the 1975 ICOM Venice concentrated on this and related problems.

22 This type of repair, known as "semi-transfer", used to be widely practiced in the United States, Germany, Italy, and Great Britain. See 1931 GELDER, pp. 67–69; 1963 THOMSON, pp. 165–168 (Lucas).

23 An inert support is one made of material that is subject to no dimensional variation in any direction under any circumstances (i.e. variations in humidity make it neither shrink nor swell, variations in temperature or radiation cause no sublimation, etc.). Most inert supports are made of superimposed sheets in which the stresses cancel one another out (e.g. plywood) or of non-inert materials impregnated with stabilizers (e.g. wood impregnated with modern resins under a vacuum and polymerized *in situ*). *S.B.*

24 Other inert supports besides plywood are blockboard (two sheets of veneer enclosing a lot of juxtaposed parallel laths) and honeycomb board, in both of which opposing stresses cancel one another out.

25 In the USSR, for example, even very badly curved icons are not as a rule straightened.

26 Straightening a panel by making it gradually absorb moisture has often been thought to be a satisfactory solution, but there is a risk of the warp reappearing.

27 "It was first necessary to flatten the surface: to achieve this a piece of gauze was glued to the painting and the painting turned over; after this Citizen Hacquin made little grooves in the thickness of the wood at some distance from one another and extending from the top edge of the center to the place where the wood support offered a straighter surface.... He placed little wedges of wood in these grooves; he then covered the whole surface with damp cloths, which he deliberately renewed. The wedges, swelling with moisture and pressing against the softened wood, forced this back into its original shape: the two edges of the aforementioned split came together; the artist then introduced a powerful glue to join the pieces together; finally he affixed oak crosspieces to hold the picture in the

shape it had just resumed while the glue dried." (1802 VINCENT.) The painting is now in the Vatican Museum.

28 The transfer process is described in detail in another volume in this series.

29 "Rubens' picture, painted on wood and representing a village wedding... is badly damaged by a large split; this is undoubtedly due to the poorly-constructed cradle that was affixed to the back of the work more than thirty years ago. Hacquin Sr., inventor of new types of cradle that move and prevent damage to the wood due to seasonal changes, requires two hundred *livres* to repair the picture with a new cradle." (1904 HACQUIN.)

30 This process was perfected by the Rome Central Institute of Restoration.

31 1953 CARITA; 1956 CARITA.

32 This was the system adopted by the painting restoration department of the French National Museums; it was conceived by M. Bazin, curator in chief, and perfected and executed by Messrs Huot and Perche of the cabinet-makers' shop.

33 1955 VILLIERE, pp. 160, 190.

34 The thickness of the acrylic sheet will depend on the size of the painting. Consequently its use on large paintings is ruled out by the weight problem. If the panel has a tendency to warp, so-called retaining cleats can be glued on the back to pass through holes in the acrylic. This is another system used at the French National Museums, where it was invented by M. Guilly, curator, and designed for execution by Messrs Huot and Perche.

35 This was the position adopted by the Brussels Royal Institute when they were treating the support of Rubens' *Deposition* (Antwerp Cathedral). See 1963 PHILIPPOT, p. 26.

Textile technology

36 We have confined ourselves here to a brief historical survey of the two main types of repair made to canvas supports – namely relining and transfer – with a comparative look at the different adhesives used. The types of deterioration affecting canvas supports are listed in the table on p. 107, together with their causes and treatment. Finally, here are one or two observations on textile technology:

Types of textile

Textiles are characterized in three ways:

1. The *type of fibre* used. This may be: (a) vegetable, i.e. flax, hemp (used in Italy in the seventeenth century), cotton, or jute (in the nineteenth century, but only rarely), all of which consist of cellulose; (b) animal, i.e. silk as encountered in eastern painting but also occasionally in Europe (there are silk paintings by Poussin and Guido Reni, among others); or, in the twentieth century, (c) of artificial or synthetic manufacture.

2. The *weave* or design of the material, i.e. the way in which the threads are interwoven. There are two main types of weave for painting canvases: (a) plain weave, which is reversible (the same on both sides) and is the type generally used in France, Italy, and Flanders (fig. 23); (b) twill weave, which has a "right" and a "wrong" side and is found in eighteenth-century English paintings (ill. 31); derived from twill weave are the so-called "herringbone" canvases so popular with Venetian painters (ill. 29; fig. 23a) and the intricate damask weaves in various patterns used by so many seventeenth-century Bolognese painters as well as by Murillo (ill. 30).

3. Its *density of weave* or texture, which depends on the gauge and spacing of the thread. A canvas may be closely, evenly, or loosely woven. The sixteenth-century Venetians, for example, used a coarse, densely-woven type of canvas; Caravaggio and Poussin used a loose-textured canvas that gave the painted surface a "pavement" type of structure (ills. 27, 28) with paint spread fairly generously with a spatula; eighteenth-century French painters

such as Boucher used a fine, evenly-textured canvas. An artist's choice of canvas strongly influences the aesthetic aspect of his work. See also 1960 WOLTERS.

Hygroscopicity of cellulose

One of the properties of cellulose is to absorb water from the atmosphere. When it does this the material shrinks; when it dries out on the other hand the material expands. These alternating stresses cause what is known as textile "fatigue". Very important in the case of new material, this phenomenon is less so in material of a certain age, which no longer reacts in this way and is appropriately said to be "dead".

Conservation

How long and how well a piece of material will last depends on two factors:

1. The *aging of the cellulose:* Cellulose is a compound of hydrogen, carbon, and oxygen and is composed of very large numbers of carbohydrate molecules forming long chains or macromolecules; the length of the fibres is a function of the number of molecules forming a chain, and their strength is a function of their length.

Cellulose ages as a result of various factors, all of which have the effect of breaking up these chains: ultra-violet rays bombard them with energy; damp and heat cause hydrolysis of the cellulose, making the molecules split up; mildew breaks up the chains by feeding on them; sulphurous gases combine with moisture and oxygen to form sulphuric acid, which again attacks the chains; and finally the presence of iron acts as a catalyst on this last reaction. *S.B.*

2. The *type of weave:* Material using thick thread woven closely is stronger and will therefore probably last longer than loosely-woven material using finer thread, and twill-woven material, since it allows a denser weave than any other type, is often the strongest of all.

37 1967 THOMSON; 1976 HOURS, pp. 21, 34.

38 1960 WOLTERS, p. 160 note 3.

39 1933 STOUT; 1934 PLENDERLEITH; 1974 *Conference on Comparative Lining Techniques;* 1974 URBANI; 1975 ICOM VENICE, Group 11.

40 1972 MAKES.

41 French relining glues include wheat-flour paste, rye-flour paste, and animal glue with various additives (linseeds, Venice turpentine, honey, carbolic acid, etc.) depending on the individual reliner.

42 The traditional Italian relining glue is "linseed flour – animal glue – wheat flour – rye flour" (1866 SECCO-SUARDO.

43 1974 *Conference on Comparative Lining Techniques* (Yashkina).

44 1969 PHILIPPOT.

45 1684 PILES (1766 edition), pp. 169-170. This is one of the earliest French works describing a relining.

46 1968 RUHEMANN, pp. 434-436. A flexible envelope experimented with in England avoids accentuating the weave imprint, which is a fault of the hot table; see 1975 ICOM Venice, Group 11 (6. Lewis).

47 1947 SCHENDEL.

48 1970 SOLDENHOFF; 1974 *Conference on Comparative Lining Techniques* (Percival-Prescott); 1975 ICOM Venice, Group 11 (2. Berger-Zeliger).

49 1967 LODEWIJKS.

50 1972 MEHRA; 1975 ICOM Venice, Group 11 (5. Mehra).

51 1950 MAROT.

52 He was in Paris from 1797 to 1815.

53 1965 MARCONI.

54 1968 HENDY.

55 Late 11th/early 12th century THEOPHILUS; 1437 CENNINI; 1550 VASARI; 1620 MAYERNE; 1708–1715 PALOMINO; 1830 MERIMEE – to quote only one author per century.

56 1976 HOURS, pp. 85–99.

57 The paint layer becomes more transparent as time goes on, the index of refraction of the oil increasing to approach that of the pigment; the whole behaves as a homogeneous medium. *S.B.*

58 1960 DELBOURGO.

59 A thin, translucent coat of paint allowing the ground to which it is applied to show through in places.

60 Animal glues extracted from rabbit skin, bone, cartilage, beef sinew, parchment clippings, or fish (i.e. the swimming bladders of cartilaginous species such as the sturgeon) are proteinic. Their active principle is gelatine. Casein is a glue made from curdled milk. *S.B.*

61 The siccativity or drying capacity of an oil is a complex phenomenon. Drying occurs through "bridging" between the chains of macromolecules and may take place with or without fixation by means of foreign elements (metallic additives, oxygen, etc.). Painters learned early on to increase the siccativity of their oils by heating them in a bain-marie, exposing them to sunlight (i.e. to the action of ultraviolet rays), or adding various metallic elements such as white lead, litharge (lead oxide). *S.B.*
 Essential oils or essences are obtained by distilling either plants (French lavender for spike oil, rosemary, cajuput) or pine balsam (turpentine); a so-called mineral oil is petroleum, which when distilled produces the highly volatile white spirit that was already known in seventeenth-century Italy by the name of "olio di Sasso" or "olio di Pietra". See 1959 LANGLAIS, p. 158.

62 1959 LANGLAIS, pp. 420–421; 1963 *Synthetic Materials;* 1974 HAVEL, pp. 65–66.

63 1437 CENNINI, pp. 25–44. The usual simple palette consists of seven colors each obtained with a certain number of pigments whose use has varied down the centuries:
 For their *blues* the Primitives used mainly azurite (copper carbonate) and lapis lazuli (sodium alumino-silicate); these were gradually replaced by smalt in the seventeenth-century (glass colored with cobalt and then ground) and by the Prussian blue (ferric ferrocyanide) discovered by Diesbach in 1704.
 The original *greens* consisted of green earth pigment (hydrated ferric oxide), verdigris (copper acetate), malachite (copper carbonate), and copper resinate; these came to be replaced by chrome greens from 1809 onwards and by the so-called "emerald" green (copper arseniate) discovered at Schweinfurt in 1814.
 The early *reds* were earth pigments (ferrous oxides), cinnabar or vermilion (mercuric sulphide, first as found in nature and later synthesized), minium (lead oxide), and madder lake (with the color usually being fixed on alumina).
 Early *yellows* were earth pigments (ferrous oxides), litharge and massicot (lead monoxide), orpiment and realgar (tri- and disulphides of arsenic), yellow lead, and yellow tin; they were replaced from 1809 onwards by chrome yellows (lead chromate) and the cadmium yellows (cadmium sulphide) that Stromeyer started discovering in 1817.
 Browns were always earth pigments (ferrous oxides burned to a lesser or greater degree, e.g. Sienna earths and umbers (the latter being more hydrated and more transparent); bitumen (various oxygenated hydrocarbons) was also used.
 Blacks were either carbon black (carbon alone) or bone or ivory black (carbon and phosphorous).
 The classic *whites* are lime (calcium carbonate) or gesso or gypsum (calcium sulphate), both of which have rather poor covering power, or white lead (lead carbonate) with its high covering power. It was not until the end of the eighteenth century and above all during the nineteenth century that the even more effective titanium and zinc whites (the obides of their respective metals) appeared. *S.B.*

64 1955 WOLTERS. The author demonstrates the presence in a thirteenth-century Tuscan painting of oil and oleo-resinous glazes in (for the period) unprecedented proportions.

65 1962 COREMANS tells us the materials Rubens used for his *Deposition* (Antwerp Cathedral).

66 1755 CAYLUS.

67 1921 DOERNER, pp. 139–140; 1974 *Conference on Comparative Lining Techniques*, pp. 29–32 (Percival-Prescott).

68 A *glaze* is a transparent coat of paint containing plenty of medium laid on top of an opaque, reflective coat whose value it heightens (e.g. a madder lake on top of a vermilion).
Impasto refers to the thickness of the paint as applied and to the greater or lesser degree of relief that it presents.

69 The term *"exudate"* refers to the rising of medium to the surface, giving the colors maximum depth and transparency. See 1966 PHILIPPOT.

70 Mastic resin is extracted from the tree *Pistacia lentiscus,* which grows on the shores of the Mediterranean; dammar is extracted from the tree *Dammara orientalis,* which grows in Java, Borneo, the Philippines, etc.

71 There are two types of copal: hard copal or copalite is a fossil resin; soft copal is extracted from various tropical trees growing in Zanzibar, Madagascar, etc. Amber or succinite is also a fossil resin. Copalite dissolves only after pyrogenation, which breaks down certain of its constituents. *S.B.*

72 Studies appear to justify this conclusion. See 1975 ICOM Venice, Group 22 (1. Emile-Mâle; 7. Petit).

73 All resins, whether ancient or modern, are subject with aging to reticulation or cross-linking, a classic process of macromolecular evolution. Reticulation is the result of either polycondensation (e.g. mastic or dammar resin) or polyaddition (e.g. acrylic or vinyl resins). It is reticulation that is responsible for resins being insoluble in the solvent with which they were applied and hence irreversible in the strict sense. *S.B.*

74 Smalt in an oil medium was much used in the seventeenth century. It is actually glass colored with cobalt and ground to a fine powder. Each grain of blue may gradually lose color through formation of an organo-metallic compound. See 1969 PLESTERS; 1970 GIOVANOLI.

75 1972 LANK, pp. 809–813.

76 How well paint layers adhere to one another and to the ground depends on the proportions of oil present in them. In the case of an oil ground, for example, the paint will hold well if the ground contains little oil and poorly if it contains a lot. See 1974 HAVEL, pp. 87–88.

77 Drying inhibitors, as their name suggests, work against the normal process of drying. In the case of oil they need to keep out ultra-violet rays and prevent fixation of the oxygen content (e.g. sulphur, an impurity of lapis lazuli, inhibits fixation of the oxygen for bridging the oil macromolecules). *S.B.*

78 Bitumen or asphalt is a hydrocarbon occuring in solid and liquid states; it is extracted from petroleum by evaporating the volatile parts and oxidizing the rest, and it is partially soluble in oil. See 1942 GETTENS, p. 94.

79 1959 LANGLAIS, pp. 72–73; 1969 BAZIN, pp. 8–9.

80 When such craquelure is very pronounced, does not extend over the whole surface, and has filled up with dirt, the restorer may, having first removed the dirt with a scalpel, glaze the bottom of the cracks. This treatment is only admissible in exceptional cases, however, since there is a risk of disguising the historical evolution of the work for purely aesthetic reasons.

81 1972 ALTHÖFER.

82 1976 HOURS, pp. 83–90.

83 This is a controversial field. Some authorities attribute this type of deterioration to ammonium sulphate. See 1967 MARIJNISSEN, p. 154.

84 1964 GUILLERME, pp. 103-104; 1967 MARIJNISSEN, pp. 66-67. Remember that the action of a strong base (e.g. soda, potassium, ammonia) or a weak base (e.g. an amine with water) on oil has nothing to do with solubility: it is a chemical reaction, breaking down the oil chemically. *S.B.*

85 Bloom or microfissuring of the varnish layer may be due to certain constituent elements of the varnish having partially dissolved in water. This suggestion was made to me orally by M. Jean Petit, director of the French National Scientific Research Center's Applied Macromolecular Chemistry Lab-

oratory. M. Petit was good enough to tell me about the first results of his researches after his paper at the Venice conference (1975 ICOM Venice, Group 22, 7. Petit). Reconditioning bloom means bringing together the lips of the microfissures by softening them with a solvent.

86 The method invented by the German doctor Max von Pettenkofer consisted in laying the picture face down over a chest containing cloths soaked in alcohol. In 1870 it seemed to solve all the restorer's varnish problems since it restored the transparency of the varnish layer without the necessity for reducing it. A large number of paintings in the Munich Pinakothek were treated in this way, but critical voices were raised and the method was abandoned. Alcohol is not good for oil paint and there was a danger, in so non-selective a method, of its attacking the glazes.

87 1963 BRANDI, pp. 144–147.

88 It is a question of lixiviation or dilution of an old binding agent upon contact with a solvent; there is no reaction on the polymerized section, but there is a residue from the decomposition of the bond. *S.B.* See also 1965 JONES.

89 Solvents are generally classified as follows:
1. Solvents of undefined chemical structure, e.g. such natural products as spike, rosemary, cajuput, and turpentine oil;
2. Solvents with a specific chemical structure, e.g. simple hydrocarbons, chlorinated compounds, and alcohol, ester, ketone, amine, and amide compounds.
It is very difficult to lay down rules about mixtures. What is certain is that a mixture can be more active than each body separately, so the first rule ist prudence. *S.B.*
See also 1942 GETTENS; 1963 *Synthetic Materials;* 1975 ICOM Venice, Group 21 (7. Dauchot-Dehon).

90 1950 HUYGHE *(Alumni)* p. 261.

91 1974 *An Exhibition of Cleaned Pictures,* Catalogue.

92 1950 HUYGHE *(Museum);* 1950 HUYGHE *(Alumni).* For a complete bibliography of the con-

troversy, see 1968 RUHEMANN, pp. 405–406, 428–432.

93 1966 PHILIPPOT. Patina is the normal effect of time on the work of art. "One all too frequently comes across pictures ravaged by drastic cleaning that, in altering the surface shine due to exudation of the medium, has pricked the picture's skin. A wound is opened up in which the paint appears in the material aspect it had on the palette, thus working against its own formal transfiguration." How many Primitives have been stripped of this surface shine! See 1967 MARIJNISSEN, pp. 214–215.

94 He may also use a small V-shaped cutting tool to make a small aperture the lips of which will close up again afterwards.

95 Molasses and honey, both hygroscopic, are plastifying agents; acetic acid (vinegar) is a thinning and softening agent; ox-gall, which reduces surface tension, is a softening agent.

96 Some studios have worked from the verso, introducing the glue through tiny perforations in the canvas at the points where paint was coming away. See 1933 *Mouseion,* vols. 41–42, p. 162.
M. Linard, a restorer at the French National Museums, invented a method in which the glue was made to penetrate in depth by keeping it warm and runny with the aid of carefully controlled infra-red radiation (ill. 22). In Brussels A. Philippot introduced a treatment with glue dissolved cold in red vinegar (1963 PHILIPPOT, p. 22; 1968 HENDY, p. 254). In Italy the traditional *colletta* is still used (1866 SECCO-SUARDO, p. 365: "animal glue – molasses – ox-gall – water") and in Russia sturgeon glue.

97 Beeswax has now been replaced by microcrystalline waxes; colophony (rosin) and then dammar have now been replaced by artificial resins. *S.B.*

98 1965 TORRACA. The authors' study model was designed for murals but their conclusions are also interesting as regards easel paintings. See also 1972 BERGER; 1975 ICOM Venice, Group 22 (4. Feller).

99 1963 BRANDI (this modern restoration theorist

had already worked out his position in a series of articles in the *BICR* from 1950 onwards); 1959 PHILIPPOT; 1963 *Nineteenth and Twentieth-Century Studies*; 1972 ALTHÖFER.

100 1969 PHILIPPOT, pp. 163–172.
101 If a restorer has put an anti-ultra-violet agent in his materials, ultra-violet photography will not reveal his retouching.
102 1931 RUHEMANN, pp. 19–21; 1931 GELDER.
103 Max Doerner suggested restoration by hatching as early as 1921, but with the colors mixed on the palette. See 1921 DOERNER, p. 407.
104 Glycerine and honey are among the hygroscopic materials that can be added to gouache or water-color to preserve their plasticity.
105 1932 RUHEMANN.
106 1957 EMILE-MALE, p. 402.
107 1974 HAVEL, pp. 77-85.
108 1969 BAZIN, p. 21.
109 1963 THOMSON, pp. 171-176 (Feller); 1963 *Synthetic Materials*; 1968 RUHEMANN, p. 137; 1975 ICOM Venice, Group 22 (4. Feller).
110 1974 PHILIPPOT.

ACKNOWLEDGEMENTS

This book is the product of the collective experience of restorers both living and deceased who have passed on what they knew.

I should like to express my indebtedness to those who have done so much for the Restoration Studio of the Louvre and the National Museums:

To M. Goulinat, who headed the Studio for thirty-four years (1935–69) and who together with the first teams of restorers – Messrs Aubert, Paulet, Roullet, and Linard, among others – put into practice the teachings of M. Huyghe, curator in chief from 1935 (when the Studio was set up) to 1951;

To M. Bazin, curator in chief, who for twenty years (1951–71 supervised the restoration of paintings with a competence that was recognized by all who worked with him;

To the fresh teams of restorers who, entering the Studio by competitive examination between 1958 and 1973, carried on the work of the original teams;

To the relining shop (headed by M. Rostain);

And to the cabinet-makers' shop (Messrs Huot and Perche).

My special thanks are due to:

M. Roullet, the present head of the Studio, for the interest he has taken in my book;

Mlle S. Bergeon, curator, for her careful assistance as regards both construction and documentation. The scientific and technological notes and diagrams signed 'S.B.' are by her.

And Mme Leblanc for her valuable help with the final checking.

G. E-M.

123

BIBLIOGRAPHY

Abbreviations:

TS Technical Studies in the Field of Fine Arts. Fogg Art Museum, Harvard University, Cambridge, Mass.

SC Studies in Conservation. London.

BICR Bolletino dell'Istituto Centrale del Restauro. Rome.

BIRPA Bulletin de l'Institut Royal du Patrimoine Artistique. Brussels.

ICOM International Council of Museums, fourth triennial conference, Venice, 13–17 October 1975.

Late 11th/early 12th century: THEOPHILUS. *Diversarium artium schedula.*

1437 CENNINI, C. *Il libro dell'arte o trattato della pittura.*

1550 VASARI, G. *Le Vite de' piu eccellenti Architetti, Pittori, et Scultori Italiani*, 2nd enlarged edition (English trans.: "Lives of the Artists").

1620 MAYERNE, T. DE. *Pictoria Sculptoria et quae subalternarum artium.* Manuscript, British Museum, Sloane Foundation no. 2052, presented by M. Faidutti and C. Versini, Lyon.

1684 PILES, R. DE. *Elémens de Peinture pratique.* Reprinted Geneva: 1973.

1705–15 PALOMINO, A. *Museo Pictorico y escala optica.* Madrid.

1755 CAYLUS, COMTE DE, AND MAJAULT, M. *Mémoire sur la peinture à l'encaustique et sur la peinture à la cire.* Geneva.

1802 VINCENT, TAUNAY, GUYTON, BERTHOLET. "Rapport de l'Institut National sur la restauration du Tableau de Raphael: La Vierge de Foligno." In PASSAVANT, J. D. *Raphael d'Urbin et son père Giovanni Santi.* Vol. 2, 622–629. Paris: 1860.

1830 MÉRIMÉE, J. F. L. *De la peinture à l'huile.* Edited by Mme Huzard-Vallat.

1866 SECCO-SUARDO, G. *Manuale ragionato per la parte meccanica dell'arte del restauratore di dipinti.* Milan.

1904 HACQUIN. "Lettre de Pierre à Marigny, 18 septembre 1770." In *Nouvelles archives de l'art français.* 3rd series, 20 (1904): 212.

1921 DOERNER, M. *Malmaterial und seine Verwendung im Bilde.* Munich. English trans.: E. Neuhaus. *The Materials of the Artist and their Use in Painting.* Revised edition. New York: 1962.

1931 RUHEMANN, H. "La technique de la conserva-

tion des tableaux. 5. Restauration par adjonctions reconnaissables." In *Mouseion*. 15: 19–21.

1931 GELDER, H. E. VAN. "Les limites de la restauration des œuvres d'art." In *Mouseion*. 15: 67–69.

1932 RUHEMANN, H. "Une méthode de restauration à la cire neutre." In *Mouseion*. 17–18: 167–168.

1933 STOUT, G. L., AND GETTENS, R. J. "The Problem of Lining Adhesives for Paintings." In *TS*. 2: 81–104.

1934 PLENDERLEITH, H. J., AND CURSITER, S. "The Problem of Lining Adhesives for Paintings – Wax Adhesives." In *TS*. 3: 90–115.

1942 GETTENS, R. J., AND STOUT, G. L. *Painting Materials*. New edition. New York: 1966.

1947 *An Exhibition of Cleaned Pictures*. Catalogue, foreword by Philip Hendy, The Trustees of the National Gallery. London.

1947 SCHENDEL, A. VAN, AND MERTENS, H. "De Restauraties van Rembrandt's Nachtwacht." In *Oud Holland*. 62: 1–52.

1950 MAROT, P. "Recherches sur les origines de la transposition de la peinture en France." In *Annales de l'Est*. 1: 241–283.

1950 CAGIANO DE AZEVEDO, M. "Una scuola napoletana di restauro nel XVII.–XVIII. s." In *BICR*. No. 1: 44–45.

1950 HUYGHE, R., BRANDI, C., SCHENDEL, A. VAN, *et al.* "The Cleaning of Pictures." In *Museum*. 3: 189–243.

1950 HUYGHE, R. "Le nettoyage et la restauration des peintures anciennes: Position du problème." In *Alumni*. 19: 252–261.

1952 BUCK, R. D. "A Note on the Effect of Age on the Hygroscopic Behaviour of Wood." In *SC*. 1: 39–44.

1953 CARITÀ, R. "Proposte per la parchettatura delle tavole." In *BICR*. No. 16: 173–188.

1955 VILLIÈRE, A., BAZIN, G., WOLTERS, C., *et al.* "The Care of Wood Panels." In *Museum*. 8: 139–194.

1955 WOLTERS, C. "A Tuscan Madonna of c. 1260: Technique and Conservation." In *SC*. 2: 87–96.

1956 CARITÀ, R. "Pratica della parchettatura." In *BICR*. Nos. 27–28: 101–131.

1956 PLENDERLEITH, H. J. *The Conservation of Antiquities and Works of Art*. London, New York, Toronto. OUP.

1956 PLESTERS, J. "Cross-sections and Chemical Analysis of Paint Samples." In *SC*. 2: 110–157.

1957 ÉMILE–MÂLE, G. "Le Brun, Jean-Baptiste Pierre: son rôle dans l'histoire de la restauration des tableaux du Louvre." In *Mémoires de Paris et de l'Ile de France*. 8: 371–417.

1959 BRANDI, C. "Il restauro della Maestà di Duccio." In *BICR*. Nos. 37–40: 3–210.

1959 LANGLAIS, X. DE. *La Technique de la peinture à l'huile*. New edition. Paris: 1973.

1959 PHILIPPOT, A. AND P. "Le problème de l'intégration des lacunes dans la restauration des peintures." In *BIRPA*. 2: 5–19.

1960 DELBOURGO, S., AND PETIT, J. "Application de l'analyse microscopique et chimique à quelques tableaux de Poussin." In *Bulletin du Laboratoire du Musée du Louvre*. No. 5: 41–54.

1960 PHILIPPOT, A. AND P. "Réflexions sur quelques problèmes esthétiques et techniques de la retouche." In *BIRPA*. 3: 163–172.

1960 WOLTERS, C., BAZIN, G., HENDY, P., *et al.* "The Care of Paintings: Fabric Paint Supports." In *Museum*. 13: 135–171.

1961 BUCK, R.D. "The Use of Moisture Barriers on Panel Paintings." In *SC*. 6: 9–20.

1961 MARETTE, J. *Connaissance des primitifs par l'étude des bois.* Paris.

1962 ALTHÖFER, H. "Die Retusche in der Gemälderestaurierung." In *Museumskunde*. 31: 75–88 and 144–170.

1962 COREMANS, P., AND THISSEN, J. "La Descente de Croix de Rubens. Etude préalable au traitement: composition et structure des couches originales." In *BIRPA*. 5: 119–127.

1963 BRANDI, C. *Teoria del Restauro.* Rome.

1963 BUCK, R.D. "Some Applications of Mechanics to the Treatment of Panel Paintings." In *Recent Advances in Conservation.* London.

1963 FILATOV, V. "Méthodes et procédés de la découverte de la couche originale des primitifs russes à la détrempe." *ICOM*, treatment of paintings subcommittee. Moscow-Leningrad.

1963 PHILIPPOT, A. AND P. "La Descente de Croix de Rubens: Technique picturale et traitement." In *BIRPA*. 6: 7–51.

1963 RUDEL, J. *Technique de la peinture.* Collection "Que sais-je?" Paris.

1963 *Synthetic Materials Used in the Conservation of Cultural Property.* International Center for the Study of the Preservation and the Restoration of Cultural Property. Rome.

1963 THOMSON, G., ed. *Recent Advances in Conservation.* IIC Rome Conference 1961. London.

1963 WOLTERS, C. "Treatment of Warped Wood Panels by Plastic Deformation: Moisture Barriers and Elastic Supports." In *Recent Advances in Conservation.* London.

1963 *Nineteenth and Twentieth Century Studies in Western Art.* Acts of the Twentieth International Congress of the History of Art. Princeton.

1964 GUILLERME, J. *L'Atelier du temps. Essai sur l'altération des peintures.* Paris.

1965 JONES, P.L. "The Leaching of Linseed Oil Films in Iso-Propyl Alcohol." In *SC*. 10: 119–129.

1965 MARCONI, B. "The Transfer of Panel Paintings on Linen by Siderov (Hermitage Museum, St. Petersburg)." In *Application of Science in the Examination of Works of Art.* Boston.

1965 TORRACA, G., AND MORA, P. "Fissativi per pitture murali." In *BICR*. No. 45: 109–132.

1966 PHILIPPOT, P. "La notion de patine et le nettoyage des peintures." In *BIRPA*. 9: 138–143.

1967 BAZIN, G. *Le Temps des Musées.* Liège-Brussels.

1967 LODEWIJKS, J. "The Latest Developments in the Conservation of Old Textiles by Means of Heat Sealing." *ICOM*, Mixed conference: laboratories and treatment of paintings. Brussels.

1967 MARIJNISSEN, R.H. *Dégradation, Conservation, et Restauration de l'Oeuvre d'Art.* Brussels.

1967 THOMSON, G., ed. *Contributions to the London*

Conference on Museum Climatology. London.

1968 HENDY, P., AND LUCAS, A.S. "The Ground in Pictures." In *Museum*. 21: 245–256.

1968 MONCRIEFF, A. "A Review of Recent Literature on Wood (January 1960 – April 1968)." In *SC*. 13: 186–212.

1968 RUHEMANN, H. *The Cleaning of Paintings: Problems and Potentialities*. London.

1969 BAZIN, G. "Introduction à la Technique Impressioniste." *ICOM*, Conservation committee. Amsterdam.

1969 *Problems of Conservation in Museums. ICOM.* Paris.

1969 PHILIPPOT, A., GOETGHEBEUR, N., AND WITTERMANN, R. "L'Adoration des Mages de Brueghel au Musée des Beaux-Arts de Bruxelles. Traitement d'un Tuechlein." In *BIRPA*. 11: 5–33.

1969 PLESTERS, J. "A Preliminary Note on the Incidence of Discolouration of Smalt in Oil Media." In *SC*. 14: 62–74.

1970 GIOVANOLI, R., AND MÜHLTALER, B. "The Investigation of Discoloured Smalt." In *SC*. 15: 37–44.

1970 SOLDENHOFF, B. "Zmiany kolorystyczne wystepujace w obrazach olejnych przy zastoswaniv dublazu woskowo – zywicznego." ("Colouristic Changes in Oil Paintings after a Wax Resin Relining"). In *Konserwacja Malarstwa, Warszawa*, Seria B, 27: 98–101.

1971 FELLER, R., STOLOW, N., AND JONES, E.H. *On Picture Varnishes and their Solvents*. Revised and enlarged edition. Cleveland, London.

1972 ALTHÖFER, H. "Les problèmes esthétiques et de retouches dans la restauration d'œuvres d'art modernes." *ICOM*, Conservation committee. Madrid.

1972 BALDINI, U., AND DEL POGGETTO, P. *Firenze restaura*. Florence.

1972 BERGER, G.A. "Testing Adhesives for the Consolidation of Paintings." In *SC*. 17: 173–194.

1972 BUCK. R.D. "Some Applications of Rheology to the Treatment of Panel Paintings." In *SC*. 17: 1–11.

1972 LANK, H. "The Use of Dimethyl Formamide Vapour in Reforming Blanched Oil Paintings." IIC Lisbon Congress.

1972 MAKES, F., AND HALLSTRÖM, B. *Remarks on Relining*. Stockholm.

1972 MEHRA, V.R. "Comparative Study of Conventional Relining Methods and Materials and Research towards their Improvement." *ICOM*, Conservation committee. Madrid.

1972 RIOLLOT, C. *Technologie Générale du Bois*. Paris.

1973 CONTI, A. *Storia del Restauro*. Milan.

1974 *Conference on Comparative Lining Techniques.* National Maritime Museum, Greenwich, April 1974. Various authors, particularly PERCIVAL-PRESCOTT, W. "The Lining Cycle."

1974 HAVEL, M. *La Technique du tableau*. Paris.

1974 PHILIPPOT, P. "Essai de typologie de la formation des spécialistes de la Conservation." In *Chroniques*. International Study Center for the Conservation and Restoration of Works of Art. Rome, 2nd year. No. 2: 2–4.

1974 URBANI, G., ed. *Problemi di Conservazione.* Bologna.

1975 *ICOM* Venice. Group 11, Frames and relining. 1. Percival-Prescott 2. Berger and Zeliger 5. Mehra 6. Lewis.

1975 *ICOM* Venice. Group 18, Nuclear application to conservation.

1975 *ICOM* Venice. Group 21, Picture layer. 7. Dauchot-Dehon.

1975 *ICOM* Venice. Group 22, Varnish. 1. Emile-Mâle 4. Feller 7. Petit.

1976 HOURS, M. *Conservation and Scientific Analysis of Painting.* Fribourg, New York.

INDEX